IMAGES
of America

SELMA

ON THE COVER: The Shady Hook Café was located on 1200 Highland Avenue. It operated at its height during Prohibition (1920–1933) and was the favorite watering hole and gathering spot for Selma's middle class. It was an alternative to the members-only Selma Country Club, which opened in 1923. (Williams/Phillips Family collection.)

IMAGES
of America
SELMA

Sharon J. Jackson

ARCADIA
PUBLISHING

Published by Arcadia Publishing
Charleston, South Carolina

Printed in the United States of America

Library of Congress Control Number: 2014938366

For all general information, please contact Arcadia Publishing:
Telephone 843-853-2070
Fax 843-853-0044
E-mail sales@arcadiapublishing.com
For customer service and orders:
Toll-Free 1-888-313-2665

Visit us on the Internet at www.arcadiapublishing.com

*To Richard "Billy" Adler Rosenberg, an expert photographer whose
extensive collection of photographs pays tribute to Selma's storied past,
and Mrs. Jean Martin, one of Selma's greatest historians and treasures.*

CONTENTS

ACKNOWLEDGMENTS

I would like to thank a number of individuals, organizations, and institutions that provided assistance and support toward the completion of this book. I owe a huge debt of gratitude to Richard "Billy" Rosenberg for his fabulous photograph collection; this book would not be possible without his discerning eye. Thank you also to Ron Rosenberg, Billy's son, for granting me access to his father's collection and to Hannah Berger and Ronnie Leet for their time and patience. A heartfelt thanks to Mrs. Anne Falkenberry Knight and the Selma–Dallas County Public Library for your dedication to maintaining the city's archives and for your friendly responses to all my questions. Thank you Mayor George Evans, Councilman Cecil Williamson, the board of the Old Depot Museum, the Smitherman Vaughn Museum, the Dinkins Family, the Black Belt African American Genealogical and Historical Society, and Mr. Minzo Driskell and the Craig Field Airport and Industrial Complex for supporting the project. I am also grateful to the following individuals, who shared their family photographs and stories: Jay Minter IV, Dorothy Jackson Brown, Brenda "B.J." Smothers, Catesby Jones, "Skip" Phillips, Shirley Quarles Baird, and Frances Bumbrey. Finally, thank you Alston Fitts III and "Historic Churches of Selma, Prior to 1925" by Madden & Associates, B.J. Smothers, and Anne Knight for reading and proofing the history drafts and for your insight and knowledge of Selma.

Helpful research sources included the Encyclopedia of Alabama, Alabama Department of Archives and History, the Library of Congress Historic American Buildings Survey and the Prints and Photographs Archive, the Veterans of the Civil Rights Movement (VCRM) website, *Selma: Her Institutions and Her Men* by John Hardy, *Civil War to Civil Rights: A Pictorial History of Selma* by Jean Martin, the *Selma Times Journal*, and *Selma: Queen City of the Black Belt* by Alston Fitts III.

Unless otherwise noted, the images in this volume appear courtesy of the Billy Rosenberg Collection (BRC); the Alabama Department of Archives and History, Montgomery, Alabama (ADAH); the Selma–Dallas County Public Library; the Library of Congress, Digital Collection (LOCDC); and Carl Bowline and Madden & Associates.

INTRODUCTION

Prior to settlement by Europeans, the area of present-day Selma had been inhabited for thousands of years by varying cultures of indigenous peoples. The Europeans encountered the historic Native American people known as the Muscogee (also known as the Creek), who had been in the area for hundreds of years.

French explorers and colonists were the first Europeans to explore this area. In 1732, they recorded the site of present-day Selma as Écor Bienville. The few white men who were in this part of the country as early as 1809 and 1810 knew this place as High Soap Stone Bluff. It retained the name until Thomas Moore from Tennessee built a trading post in the present area of Green Street and Water Avenue, and it became known as Moore's Bluff. Like most settlers of the era, Moore was a squatter without a title to his land. He would lose claim to the area he had settled on March 16, 1817, when the Alabama Legislature sold 460 acres, along the Alabama River, to William Rufus King, a politician and planter who would become a future vice president of the United States and Dr. George Phillips. The city was renamed Selma by King, with the name, meaning "high seat" or "throne," from a poem by Ossian.

In March 1819, the Selma Town Land Company was organized, and the principals included King, Dr. Phillips, George Mathews (president), Jesse Beene, Gilbert Shearer (secretary and treasurer), Thomas Cowles, and Caleb Tate. Following its organization, the company immediately issued $500,000 in certificates of stock in $100 shares. A land auction sale was held in May 1819, and 100 lots were sold for $35,431. Interestingly, perhaps out of respect or guilt, Thomas Moore, who settled the area, was allowed to purchase lots two and three.

All of the lots sold were located between present-day Lauderdale Street and Martin Luther King Jr. Street and south of Selma Avenue. The south side of Water Avenue between Broad and Lauderdale Streets was not included. The company laid out streets, drew plans of the town, and did all of the "things necessary to exhibit a plat of a very pretty little town," according to author John Hardy. There were four lots designated for churches, one for a public square, and one for a market house. On December 4, 1820, an act was passed by the Alabama Legislature that incorporated the town of Selma. By 1830, all of the lots in the town belonging to the company had been sold, and the Selma Town Land Company ceased to exist. Selma became the seat of Dallas County in 1866.

From about 1818 to 1826, the inhabitants of Selma continued to increase in number gradually, but around 1826 the city began to experience its first epidemic, and many of the settlers left, seeking a more healthy location. From 1826 to about 1830, the population diminished in number, and in response, the town authorities organized and enforced a new sanitary system. This included draining numerous ponds of offensive water found in various parts of the town and opening up ditches. These actions were effective in stopping the further spread of disease and sickness, and the population gradually increased.

Much of the early prosperity of Selma and Dallas County, one of the richest counties in the state, was due to cotton. This was the boom crop in the Old South. It grew extremely well in the fertile soil of the "Black Belt" and was marketable in England and the northeast United States, where mills took all the cotton they could obtain. Cotton was tended by the slave population, and the work producing the crop took place over a large part of the year. There were few periods of inactivity for the enslaved. Of course, the cotton had to be transported to a port of shipment, and therein lies one of Dallas County's greatest advantages. The Alabama River, easily navigable by steamboats, flowed right through the county and into Mobile Bay. Thus, Dallas County cotton

was shipped down the Alabama River on steamers to the port city of Mobile. By 1860, the Black Belt counties were each producing more than 45,000 bales of cotton a year. By 1860, Dallas County had the third-largest per-capita income in the United States.

In regard to slavery, author John Hardy wrote in his 1879 book, *Selma: Her Institutions and Her Men* the following:

> The negro population rapidly increased in both town and country. Large droves, some hundreds daily, were brought to the town by men like James Hall, Watson, Willis and Jordan, whose business it was to trade in negroes. Several large buildings were erected in the town especially for the accommodation of negro traders and their property. . . . There was a large three story wooden building, sufficiently large to accommodate four or five hundred negroes. On the ground floor, a large sitting room was provided for the exhibition of negroes on the market; and from among them could be selected blacksmiths, carpenters, bright mulatto girls and women for seamstresses, field hands, women and children of all ages, sizes and qualities. To have seen the large droves of negroes arriving in the town every week, from about the first of September to the first of April, every year, no one could be surprised at the fact that the negro population increased in Dallas county, from 1830 to 1840, between twelve and fifteen thousand. The immense wooden building thus used for twenty years, on Water Street, was taken away in 1854, by Dent Lamar . . .

CIVIL WAR

During the Civil War, Selma was one of the South's main military manufacturing centers, producing tons of supplies and munitions and turning out Confederate warships such as the ironclad warship *Tennessee*. The Selma Naval Foundry and Ironworks was considered the second-most important source of weaponry for the South next to Tredegar Ironworks in Richmond, Virginia. This strategic concentration of manufacturing capabilities eventually made Selma a target of Union raids into Alabama late in the Civil War.

The capacities and importance of Selma to the Confederate movement were noted in the North and were too great to be overlooked by Federal authorities. As the town grew in importance, the Union felt it more important to capture and control. Gen. William Tecumseh Sherman first made an effort to reach it, but after advancing as far as Meridian, within 107 miles of Selma, his forces retreated to the Mississippi River. Gen. Benjamin Grierson, with a cavalry force from Memphis, was intercepted and returned. Gen. Rousseau made a dash in the direction of Selma but was misled by his guides and struck the railroad 40 miles east of Montgomery.

On March 30, 1865, Gen. James H. Wilson detached Gen. John T. Croxton's brigade to destroy all Confederate property at Tuscaloosa, Alabama. Wilson's forces captured a Confederate courier found to be carrying dispatches from Confederate general Nathan Bedford Forrest describing the strengths and dispositions of his scattered forces. Wilson sent a brigade to destroy the bridge across the Cahaba River at Centreville, which cut off most of Forrest's reinforcements from reaching the area. He began a running fight with Forrest's forces that did not end until after the fall of Selma.

On the afternoon of April 1, after skirmishing all morning, Wilson's advanced guard ran into Forrest's line of battle at Ebenezer Church, where Randolph Road intersected the main Selma road. Forrest had hoped to bring his entire force to bear on Wilson. Delays caused by flooding, plus earlier contact with the enemy, resulted in Forrest mustering fewer than 2,000 men, many of whom were not war veterans but militia consisting of old men and young boys.

The outnumbered and outgunned Confederates fought bravely for more than an hour as more Union cavalry and artillery deployed on the field. Forrest was wounded by a saber-wielding Union captain, whom he killed with his revolver. Finally, a Union cavalry charge broke the Confederate militia, causing Forrest to be flanked on his right. He was forced to retreat under severe pressure.

Early the next morning, on April 2, Forrest arrived at Selma, "Horse and rider covered in blood." He advised Gen. Richard Taylor, the departmental commander, to leave the city. Taylor did so

after giving Forrest command of the defense. Forrest's defenders numbered less than 4,000, only half of who were dependable. The Selma fortifications were built to be defended by 20,000 men. Forrest's soldiers had to stand 10 to 12 feet apart in the works.

Generals Wilson and Eli Long arrived in front of the Selma fortifications with troops numbering close to 9,000, and a fierce battle ensued. The Federals suffered many casualties (including General Long) but continued their attack. Using vicious hand-to-hand fighting, many soldiers were struck down with clubbed muskets. In less than 30 minutes, Long's men had captured the works protecting the Summerfield Road.

After the outer works fell, General Wilson led the 4th US Cavalry Regiment in a mounted charge down the Range Line Road (Marie Foster) toward the unfinished inner line of works. The retreating Confederate forces fought back, but the Union forces were too strong.

In the darkness, the Federals rounded up hundreds of prisoners, but hundreds more escaped down the Burnsville Road, including generals Forrest, Armstrong, and Roddey. To the west, many Confederate soldiers fought the pursuing Union Army all the way down to the eastern side of Valley Creek. They escaped in the darkness by swimming across the Alabama River near the mouth of Valley Creek (where the present-day Battle of Selma reenactment is held).

Union troops looted the city that night and burned many businesses and private residences. They spent the next week destroying the arsenal and naval foundry. They left Selma heading to Montgomery and were en route to Columbus and Macon, Georgia, at the end of the war.

RECONSTRUCTION
By the end of the Civil War, the South was in a state of political upheaval, social disorder, and economic decay. The Union Army had destroyed southern crops, plantations, and entire cities. Hundreds of thousands of emancipated slaves rushed to Union lines as their masters fled the oncoming army. Inflation became so severe that by the end of the war a loaf of bread cost several hundred Confederate dollars. Thousands of Southerners were left starving, and many lost everything they owned: clothing, homes, and land.

After 1865, a plan of Reconstruction was enacted that included three major initiatives: restoration of the Union, transformation of Southern society, and enactment of progressive legislation favoring the rights of freed slaves. The 13th Amendment abolished slavery, the Civil Rights Act of 1866 and the 14th Amendment granted blacks citizenship, the 15th Amendment gave African American men the right to vote, and the Civil Rights Act of 1875 attempted to ban racial discrimination in public places.

Reconstruction was a mixed success. By the end of the era, the North and South were once again reunited, and all Southern state legislatures had abolished slavery in their constitutions. Following the end of the war, Benjamin Sterling Turner, born a slave in 1825, was a successful businessman in Selma. In 1867, Turner was elected to be Dallas County's tax collector, and in 1869 he became a councilman for the city of Selma, the first African American to do so. In March 1871, Turner was elected to serve in the 42nd Congress. He was Alabama's first black member and the second black to serve in the US House of Representatives. Jeremiah Haralson became the first African American member of the Alabama House of Representatives in 1870. He served in the state senate in 1872 and was elected as a Republican to the 44th US Congress in March 1875.

Reconstruction, though, failed in most other ways. When Pres. Rutherford B. Hayes ordered federal troops to leave the South in 1877, former Confederate officials and slave owners gradually returned to power. Southern state legislatures quickly passed "black codes," imposed voter qualifications, and allowed the sharecropping system to thrive, ensuring that the standard of living did not improve for freed slaves.

JIM CROW AND THE CIVIL RIGHTS MOVEMENT
Like other Southern states where white Democrats regained political power after Reconstruction, Alabama imposed Jim Crow laws of racial segregation in public facilities and other elements of white supremacy. At the turn of the 20th century, it passed a new constitution, with electoral

provisions such as poll taxes and literacy tests, which effectively disfranchised most blacks and many poor whites.

In early 1963, Bernard and Colia Lafayette of the Student Nonviolent Coordinating Committee (SNCC) began organizing for the right to vote in Selma alongside local civil rights leaders Sam, Amelia, and Bruce Boynton; Rev. L.L. Anderson of Tabernacle Baptist Church; J.L. Chestnut, Selma's first African American attorney; Rev. Frederick D. Reese, school principal and president of Dallas County Voters League (DCVL); Southern Christian Leadership Conference (SCLC) Citizenship School teacher Marie Foster; public school teacher Marie Moore; Ulysses Blackmon; Earnest L. Doyle; James Gildersleeve; Rev. J.D. Hunter; Rev. Henry Shannon Jr.; and others active with the DCVL.

Against fierce opposition from Dallas County sheriff Jim Clark and his volunteer posse, blacks continued their voter registration and desegregation efforts, which expanded during 1963 and the first part of 1964. Upon his arrival in Selma, Stokley Carmichael, a prominent leader in the Student NonViolent Coordinating Committee (SNCC), stated:

> The one thing SNCC did not have to do in Selma was identify and develop grassroots community leadership. As I said, this was a self-contained community, and its Dallas County Voter's League had a mighty impressive group of leaders. Some proud, fearless black leaders who, against all odds, had never quit and never backed down. They were mostly professional people: ministers like the Reverend Lewis L. Anderson and the Reverend F.D. Reese; Dr. Sullivan Jackson, a dentist; tough-talking, indefatigable attorney J.L. Chestnut; and of course, the president, Mrs. Amelia Platts Boynton, a former teacher and widely respected leader.

Beginning in January 1965, the SCLC and SNCC initiated a revived Voting Rights Campaign designed to focus national attention on the systematic denial of black voting rights in Alabama, and particularly Selma. After numerous attempts by African Americans to register, resulting in more than 3,000 arrests, police violence, and economic retaliation, the campaign culminated in the Selma to Montgomery marches—initiated and organized by the SCLC's director of direct action, Rev. James Bevel, following the killing of Jimmie Lee Jackson. This represented one of the political and emotional peaks of the modern civil rights movement.

On March 7, 1965, approximately 600 civil rights marchers departed Selma on US Highway 80, heading east to march to the capital. When they reached the Edmund Pettus Bridge, only six blocks away, they were met by state troopers and local sheriff's deputies, who attacked them, using tear gas and billy clubs, and drove them back to Selma. Because of the attacks, this became known as "Bloody Sunday."

On March 21, 1965, a Sunday, approximately 3,200 marchers again departed for Montgomery. They walked 12 miles per day and slept in nearby fields. By the time they reached the capitol four days later on March 25, their strength had swelled to around 25,000 people.

The events at Selma helped increase public support for the cause, and that year the US Congress passed the Voting Rights Act of 1965. It provided for federal oversight and enforcement of voting rights for all citizens in states or jurisdictions where patterns of under-representation showed discrimination against certain populations, historically minorities.

In 1968, Dr. Martin Luther King returned to Selma to announce that the city had made more progress than any other city in the South. He was particularly pleased that Sheriff Clark had been defeated for reelection and that Dallas County's new sheriff, moderate Wilson Baker, had appointed black deputies.

Selma continues to make history in its quiet way. In 2000, James Perkins Jr. won election as Selma's first African American mayor. In 2010, Selma native Terri Sewell became the first African American woman elected to the US Congress from Alabama.

One

THE EARLY YEARS
OF THE "QUEEN CITY

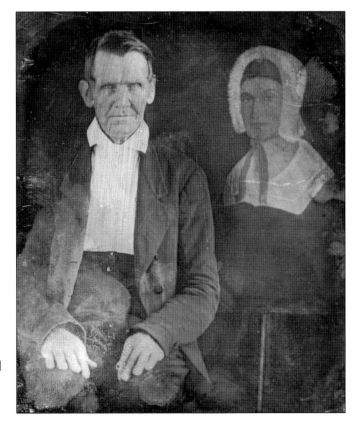

When European settlers arrived in the area of present-day Selma, they encountered the historic Native American people known as the Muscogee, or the Creek, who had been in the area for hundreds of years. In the years prior to the Creek War (1813–1814), there were Creek Indians who had farmsteads all along the Alabama River, including near present-day Selma. The few white men in this part of the country in 1809–1810 called the area High Soap Stone Bluff. Henry and Bessie Jordan, from East Tennessee, were reportedly members of a group of early pioneer settlers of Selma. Due to the climate and the "ravages and chills, and other kinds of malarial diseases," they left after about a year. (ADAH.)

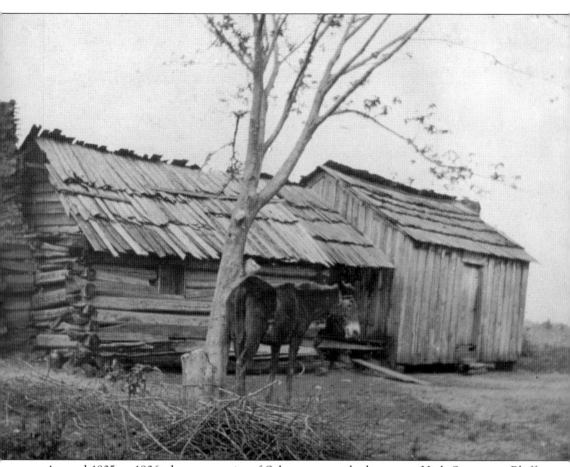

Around 1805 or 1806, the present site of Selma came to be known as High Soapstone Bluff. It retained the name until 1817, when Thomas Moore, from Tennessee, changed it to Moore's Bluff. Moore built a trading post in the present area of Green Street and Water Avenue. He and his family supported themselves primarily through hunting and fishing, and they were the only inhabitants of the area for about a year; however, like most settlers of the era, Moore was a squatter without a title to his land. Moore would lose claim to the area he had settled on March 16, 1817, when the Alabama Legislature sold 460 acres along the Alabama River to William Rufus King, a politician and planter who would become a future vice president of the United States, and Dr. George Phillips. King renamed the area Selma, with the name meaning "high seat" or "throne." Moore would eventually leave the area seeking a healthier climate. (BRC.)

William Rufus DeVane King was born in 1786 to a large, wealthy, and well-connected family. Trained as a lawyer, he represented North Carolina in Congress from 1811 to 1816, when he resigned to serve as a US diplomat in Italy and Russia. King relocated to Alabama in 1817, and his public-service career included helping to draft the state constitution, serving as a US senator (1819–1844), acting as minister to France (1844–1846), and being elected vice president on the ticket with Franklin Pierce. Severely stricken with tuberculosis, King was in Cuba seeking treatment and was allowed to take the oath of office in Matanzas, Cuba, on March 24, 1853. Unfortunately, his health did not improve, and he returned to Selma. He died on April 18, 1853, after only 45 days in office, and is his tomb is located in Old Live Oaks Cemetery. (ADAH.)

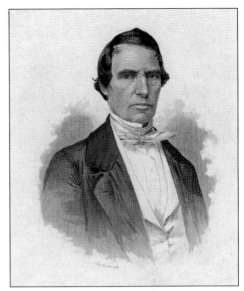

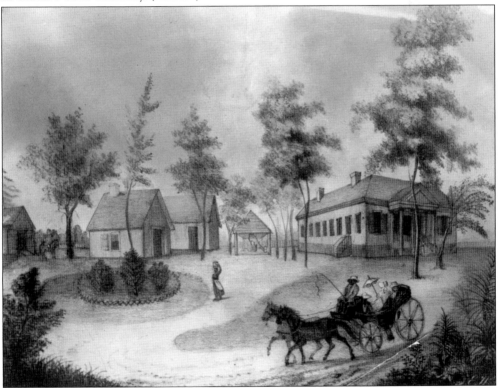

In March 1817, King and Dr. George Phillips purchased 460 acres on the Alabama River and named the region Selma. In 1818, King established a plantation at King's Bend, between Selma and Cahaba, along the Alabama River. The large cotton plantation was called Chestnut Hill and featured an oversized oak named Prince Charley, which was given to King by General Lafayette in 1825. The home burned down in the 1920s. Though he was considered a modernist on slavery, King and his relatives formed one of the largest slaveholding families in the state, collectively owning as many as 500 people. (ADAH.)

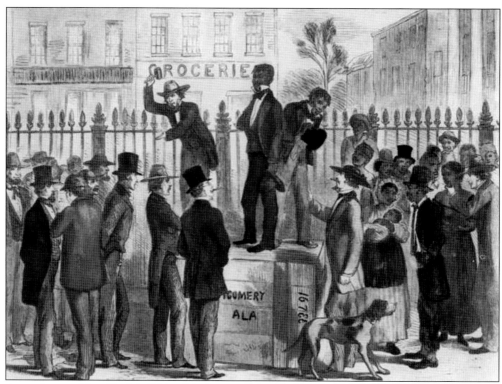

According to John Hardy's *Selma: Her Institutions and Her Men*, "The negro population rapidly increased both in the town and county. Large droves, some hundreds daily, were brought to the town by men like James Hall, Watson, Willis and Jordan, whose business it was to trade in negroes. Several large buildings were erected in the town especially for the accommodation of negro traders and their property; the largest of which was erected on the present site of the Central City Hotel building. This was a large three story wooden building, sufficiently large to accommodate four or five hundred negroes. On the ground floor, a large sitting room was provided for the exhibition of negroes on the market and from among them could be selected blacksmiths, carpenters, bright mulatto girls and women for seamstresses, field hands, women and children of all ages, sizes and qualities. To have seen the large droves of negroes arriving in the town every week, from about the first of September to the first of April, every year, no one could be surprised at the fact that the negro population increased in Dallas county, from 1830 to 1840, between twelve and fifteen thousand." (ADAH.)

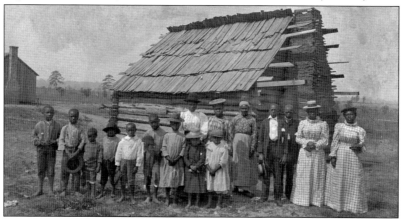

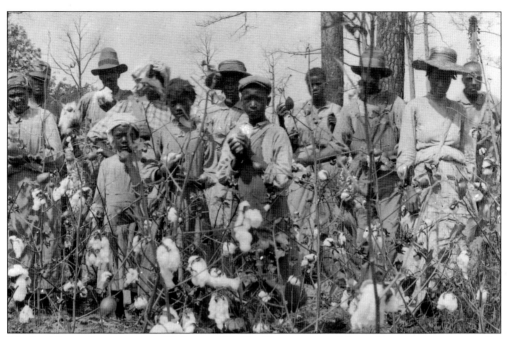

Much of the early prosperity of Selma and Dallas County, one of the richest communities in the state, was due to cotton, the boom crop in the Old South. It grew extremely well in the fertile soil of the Black Belt and was marketable in England and the northeast United States where mills took all the cotton they could obtain. Cotton was tended by the slave system, and the work producing the crop took place over a large part of the year. There were few periods of inactivity for the enslaved. The Alabama River, easily navigable by steamboats, flowed right through the county and into Mobil Bay. Thus, Dallas County cotton was shipped down the Alabama River on steamers to the port city of Mobile. By 1860, the Black Belt counties were producing more than 45,000 bales of cotton a year and Dallas County had the third largest per capita income in the United States. (Old Depot Museum and BRC.)

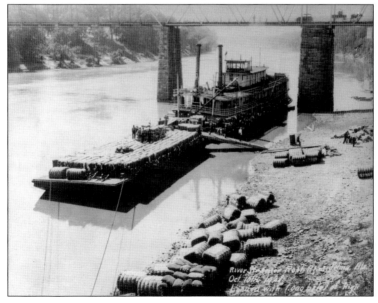

Thornton Boykin Goldsby, born in 1796, was reportedly a cousin of George Washington. Thornton moved to the Summerfield area of Selma around 1835 and married Sarah Smith. The Goldsbys became successful planters and cotton farmers on some 10,000 acres throughout Alabama, Louisiana, and Mississippi. An avid horseman, Thornton purchased land from the Kenan family in Summerfield in 1839, where he bred thoroughbred horses, built a racetrack and grandstand, and hosted regular races. Thornton's famed horse, Brown Dick, was bred on his farm, and in 1852 he was the fastest horse in the South. The multi-talented Thornton and John W. Lapsley were the major investors in the Selma and Tennessee Railroad. Thornton also helped to found the Dallas Academy, served on its board, and constructed substantial brick buildings on the corner of Broad and Alabama Streets. When he died in 1858, his will stated that he was leaving "a significant enough fortune to sustain his family for generations to come." His real and personal assets were valued at $639,500 and $273,400, respectively. Unfortunately, the Civil War exacted a huge toll on the family, and by 1936 only a few remnants remained of the vast estate. (Selma–Dallas County Public Library.)

Delia Goldsby was born into slavery around 1845 and lived her entire life in the Summerfield area of Selma. Delia, her mother Martha, and other family members were acquired by Thornton Goldsby in a horse race. Delia's owner, Colonel Mitchell, a neighboring plantation owner, was so confident his horse could beat Goldsby's fabled horse, Brown Dick, he wagered one of his plantations and slaves. Brown Dick won easily, and Delia and her family members became the property of Mr. Goldsby. Delia married Joe Goldsby, the body servant of Thornton Boykin Jr. She assisted Mrs. Goldsby with the care of her children and lived to be almost 100. Delia is pictured at right in 1944 with Elizabeth "Betsy" Whitesides, the great-great-great-granddaughter of Thornton and Sarah Goldsby, at her home. Betsy is a descendant of Thornton's son George. Pictured below are six generations of Selma women around 1893. (Selma–Dallas Public Library and the Library of Congress.)

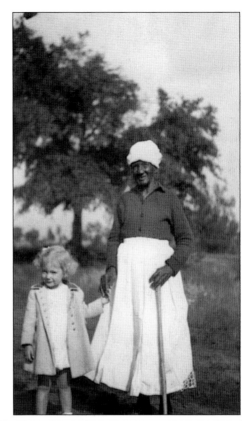

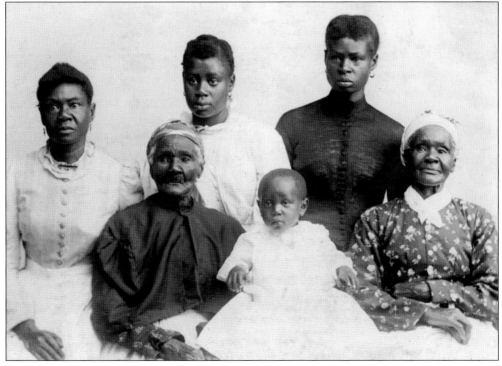

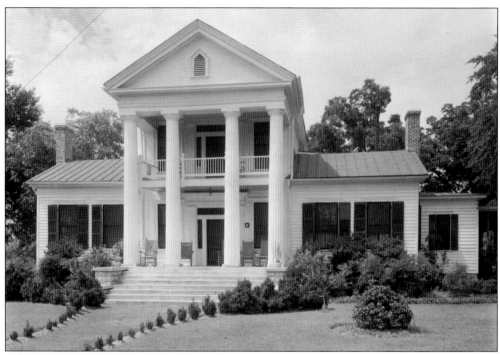

This stately, two-story plantation, at 4289 Summerfield Road, was built in 1826 by Dr. Algernon Jefferies. The home was said to have been constructed of lumber cut down on the property and of brick from a nearby kiln. It was purchased by the Kenan family in 1854. In 1865, the home was in the direct path of Union troops approaching Selma who were intent on destroying Confederate arsenals. The family buried their valuables and hid themselves to avoid surrendering. Finding little of value, the Union soldiers piled furniture and books in the front parlor yard, set them on fire, and departed. The family's servants put out the fire and saved the home. Several branches of the Kenans lived in Summerfield and had close family and business ties with Thornton Goldsby. Sadly, the ties were broken when Thornton Boykin Jr. killed Mike Kenan in a pistol duel. The two had a long-running childhood feud that caused Kenan to challenge Boykin Jr. to a duel on several occasions. Dueling was illegal in Selma, so they travelled to Benton, Alabama. They carried with them a casket that was used to carry Kenan back to Selma. (LOCDC.)

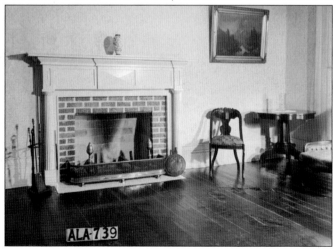

This image shows a view down Broad Street from Water Avenue around 1885. Note the fact that the canopies allowed pedestrians to stroll up and down Broad in the cool shade in summer and kept them dry when the winter rains arrived. The carts in the lower left were known as Selma Carts, and they were made to hold two bales of cotton and tipped up to load and unload easily. (BRC.)

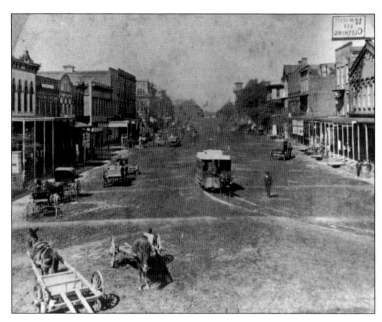

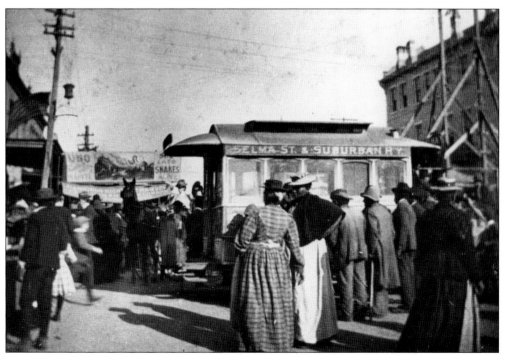

A crowd dressed in their Sunday best gathers for a street fair in downtown on the corner of Broad Street and Alabama Avenue around 1900. The Selma Suburban Rail line ran on tracks but used mule power to cover its route until it became the Selma Street and Suburban Railway, which made use of electric power. (BRC.)

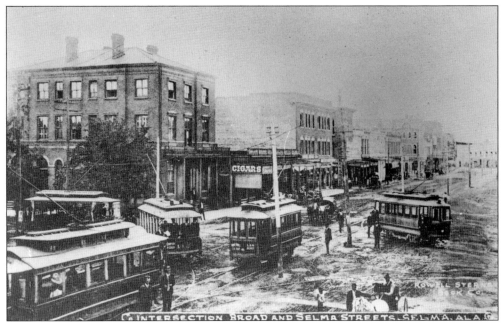

Selma's ambitious early settlers desired to be both a river and railroad town. In 1837, their first railroad, the Selma and Tennessee Rivers Railroad, failed, but they won state support for the Alabama and Tennessee Rivers Railroad in 1849. In 1855, a third railroad was launched, the Alabama and Mississippi Rivers Railroad, and by 1858 they were eager to create yet another railroad: the Selma and Gulf. (BRC.)

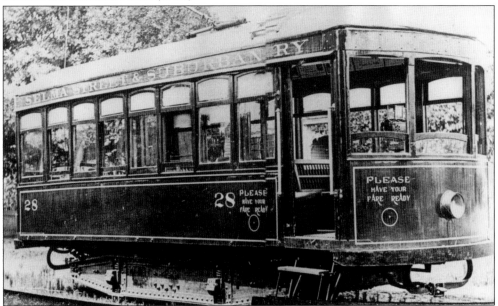

The Selma Street & Suburban Railway was chartered on December 3, 1866, and was purchased by Southern Railway in 1926. The streetcar shown here was built in Selma from the ground up. The folding step, which was later used all over the country, was invented and developed in Selma by engineer W.H. Neese and his crew. The cost of travel around town was 10¢ per trip, with a book of 20 tickets offered for a dollar. (Old Depot Museum.)

Phillip J. Weaver first arrived in Selma in 1818, and after a two-year stay in Centerville, Alabama, he returned to Selma. A prominent planter and businessman, he established some 11 downtown businesses along Water Avenue and Lauderdale Street, an area known as Weavers Corner. His interests included a boardinghouse and various other goods and services, and at one time he was the wealthiest man in south Alabama. His vast Selma plantation, located off Range Line Road (present-day Marie Foster Street), is clearly identified on Civil War maps. In 1827, he helped to found Selma's first newspaper, the *Selma Courier*, when he enticed journalist Thomas Jefferson Frow to relocate to Selma. His wife, Ann Weaver, was a member of the Ladies Educational Society, which built Dallas Academy and contributed greatly to Selma. Born in Pennsylvania in 1797, Weaver was killed in Selma in 1865, purportedly by a Union soldier, several months after Wilson's Raid on Selma. (Selma–Dallas County Public Library and BRC.)

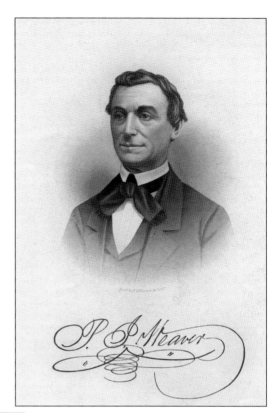

WEAVER HOUSE,

Water, Cor. Lauderdale St.

SELMA, ALABAMA.

—

MRS. JANE WINNEMORE, Proprietress.

—

THIS HOUSE is centrally located, convenient to business, public places, and street railroad, and in easy connection with all the railroads leading to and from Selma. It is in one of the most

Healthful Portions of the City,

commands a fine view of the river, and is but a short walk from the

STEAMBOAT LANDING.

The Table is spread with the best the market affords, which, with polite and attentive servants, and our aim to secure to guests the domestic comforts of home, renders this

The Most Desirable House in the City.

Transient Boarders, per day, - - $2 00

PERMANENT BOARDERS BY THE WEEK OR MONTH
ON LIBERAL TERMS.

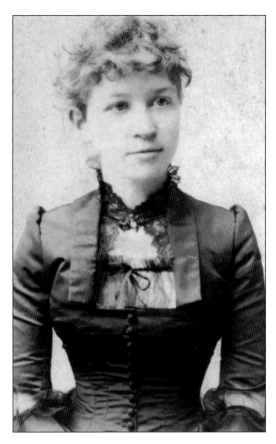

Clara Weaver Parrish (1861–1925) was born and raised at the Minter family's Emerald Place Plantation, near Selma. Her parents, William and Lucia Weaver, encouraged Clara and her siblings to develop their artistic talents. In the 1880s, Clara was sent to New York to study art at the Art Students League. By the 1890s, Clara was exhibiting widely, showing her work at the 1893 World's Columbian Exposition in Chicago and the Paris Exposition of 1900. In 1910, she exhibited at both the Paris Salon and the Royal Academy in London. Clara also achieved fame as a designer of stained-glass windows for Louis Comfort Tiffany, and her work can be seen in Selma and New York City. Clara's sister Rose Pettus Weaver (1863–1954) honed her skills as a sculptor, and her niece Anne Weaver Norton (1905–1982) excelled as an illustrator of children's books and as an abstract sculptor. Clara's great-niece Rosalind Tarver Lipscomb (born 1920) continues the artistic legacy and is an accomplished painter of portraits and landscapes. (Old Depot Museum.)

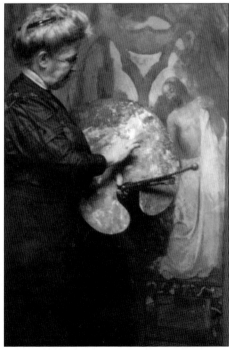

St. Paul's parish was founded in 1838 and consecrated in 1843. The original building was located on the corner of Alabama Avenue and Lauderdale Street, one block south of the present church building. In April 1865, following the Civil War Battle of Selma, Gen. James H. Wilson and his raiders burned much of the city, including St. Paul's Church. The rector, Rev. James Ticknor, was wounded in the battle, and the senior warden, Robert N. Philpot, was killed. After the war, a temporary church building was erected, and services were held there until the current building was completed in 1875. The building has changed only slightly since its construction and is adorned with beautiful stained-glass windows and an elaborate Italian mosaic altar. Three windows within the church were executed by the Lewis Comfort Tiffany Company of New York. Clara Weaver Parrish, a member of the parish, worked as a designer for Tiffany, and these windows were made as a memorial for her parents and her husband. (Selma–Dallas County Public Library and LOCDC.)

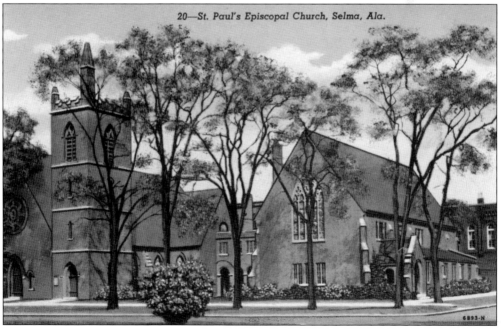

20—St. Paul's Episcopal Church, Selma, Ala.

For over 60 years, ferries were used to cross the Alabama River. Early in the 1880s, the citizens felt that there was sufficient traffic to justify a river bridge. The Selma Bridge Corporation, a private entity, was formed in 1884, with H.L. McKee, R.M. Nelson, A.L. Waller, A.M. Fowlkes, W.H. Raymond, and J.W. Stillwell as the principals. The bridge was immediately made available to the public, subject to tolls of course. To allow passage of the steamboats that plowed the river from Mobile to Montgomery, the bridge had a turn span that was operated by a bridge tender. The bridge tender's original residence, which sits next to the St. James Hotel, was recently refurbished. (BRC.)

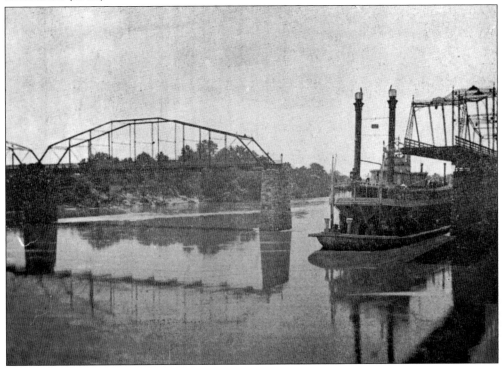

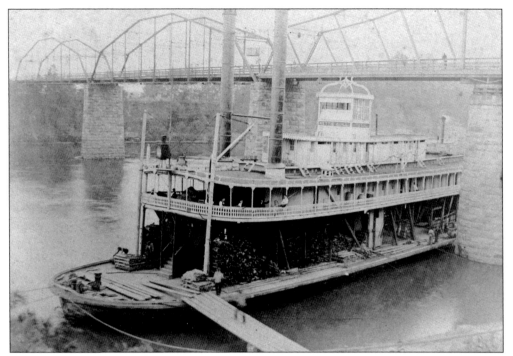

The steamboat *Nettie Quill* was a stern-wheeler that operated from 1880 to 1909. The pilothouse sat atop the ship in front of two tall smokestacks. The outside gallery, above the main deck, gave passengers the opportunity to take in the scenery and get some air. (ADAH.)

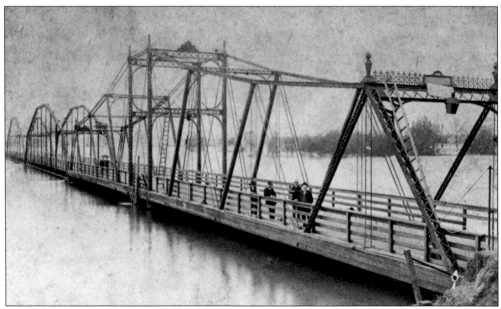

The Selma Bridge was nearly flooded in 1886. Recognizing the necessity of the bridge, on January 17, 1899, Dallas County purchased the bridge for $65,000, and the bridge became free of tolls for the use of the public. (BRC.)

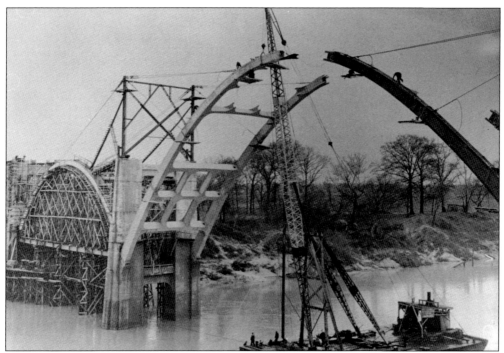

Selma's original bridge, built in the 1880s, was a horse-and-buggy span constructed for a horse-and-buggy town. Such was not the case by 1940, when the road that connected Selma with Montgomery had become a highway connection to America. On May 25, 1940, a new steel bridge along US Route 80 was opened to the public. The new link was a through-arch bridge with a central span of 250 feet, 1,248 feet in length, and 42 feet wide. The bridge was named in honor of Edmund Winston Pettus, a former Confederate brigadier general and US senator from Alabama. Selma native Henson Stephenson served as one of the project engineers. The Pettus Bridge became famous as the site of the conflict on "Bloody Sunday," March 7, 1965, when armed officers attacked peaceful civil rights demonstrators attempting to march to the state capital of Montgomery. The bridge was declared a National Historic Landmark on March 11, 2013. (BRC)

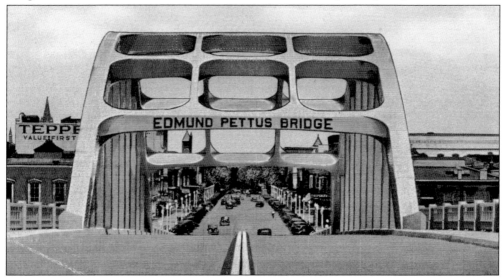

Two

CIVIL WAR AND PUBLIC SERVICE

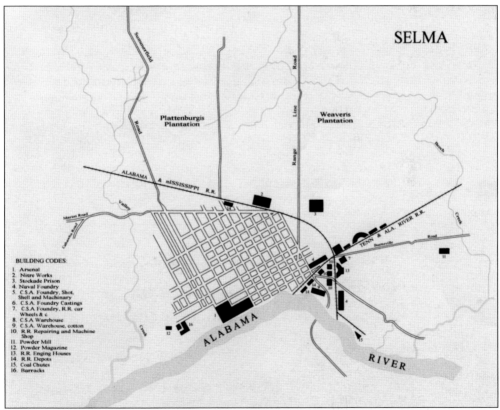

By the beginning of the Civil War, Selma had become a transportation center and went on to become one of the main military manufacturing centers supporting the South's war effort. Its foundries produced much-needed supplies, particularly iron and munitions, and its Navy yard constructed Confederate warships, including the ironclad CSS *Tennessee*, and outfitted the CSS *Nashville*. Selma's importance to the South made it one of the main targets of Gen. James H. Wilson's raid into Alabama late into the war. (Selma–Dallas County Public Library.)

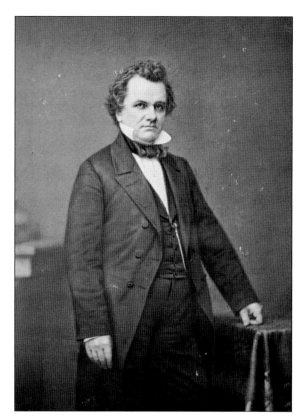

Dallas County was a political battleground during the 1850s with the "fire-eaters," who favored secession based in Cahawba, and the Unionists, who dominated in Selma. The Constitutional Unionists held their state convention in Selma on May 23, 1860, and Stephen Douglas, the Northern Democratic candidate for president, made his last major speech in Selma before going down the Alabama River to get the election returns in Mobile. Most Selmians voted for Unionist candidates, but the rest of Alabama voted to leave the Union. (ADAH.)

Jefferson Finis Davis (June 1808– December 1889) served as president of the Confederate States of America during the entire Civil War (1861– 1865). He took personal charge of the Confederate war plans but was unable to find a strategy to defeat the larger, more powerful and organized Union. His diplomatic efforts failed to gain recognition from any foreign country. At home, he reportedly paid little attention to the collapsing Confederate economy; the government printed more and more paper money to cover the war's expenses, leading to runaway inflation. This photograph of Davis was made by Hubbard & Oxford in Selma, Alabama, in 1871. (Selma–Dallas County Public Library and ADAH.)

Nathan Bedford Forrest (July 1821–October 1877) was one of the war's most unusual and controversial figures. Less educated than many of his fellow officers, Forrest had already amassed a fortune as a planter, real estate investor, and slave trader before the war. He was one of the few officers in either army to enlist as a private and be promoted to general and division commander by the end of the war. He is remembered as an innovative cavalry leader and as a leading Southern advocate in the postwar years. Although Forrest lacked formal military education, he created and established new doctrines for mobile forces, earning the nickname the "Wizard of the Saddle." A slave trader before and after the war, Forrest is associated with the massacre of black and Union prisoners at Fort Pillow. Following the war, he served as the first grand dragon of the Ku Klux Klan but later distanced himself from the organization. (LOCDC.)

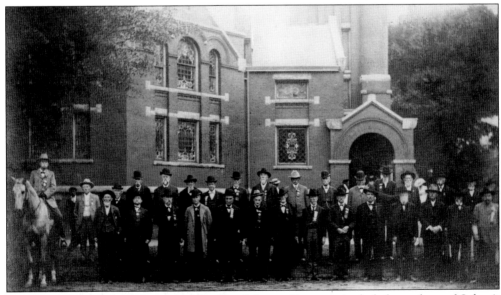

Members of the Selma chapter of the Confederate Veterans included members of Selma's founding families, such as Berry, Craig, Vaughn, Phillips, Haralson, Pitts, Burn, Lauderdale, and Mallory. (BRC.)

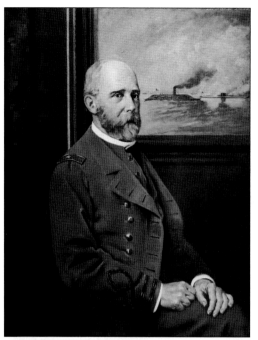

Catesby ap Roger Jones was born in Virginia; his father, Roger Jones, was the adjutant general of the United States from 1824 until his death in 1852. His uncle Thomas ap Catesby Jones was an influential US Navy commodore, and his mother was a first cousin to Robert E. Lee. Catesby's family lineage can be traced through several knights to Sir William Catesby, who served on the court of King Henry VI of England. Captain Jones (pictured) was in charge of the Confederate Selma Naval Foundry and Ironworks but is best remembered for commanding the CSS *Virginia* (formerly the USS *Merrimack*) in the battle with the USS *Monitor*. In June 1877, Catesby ap Roger Jones was shot and killed by another man as a result of a feud between his son and another man's son. (ADAH.)

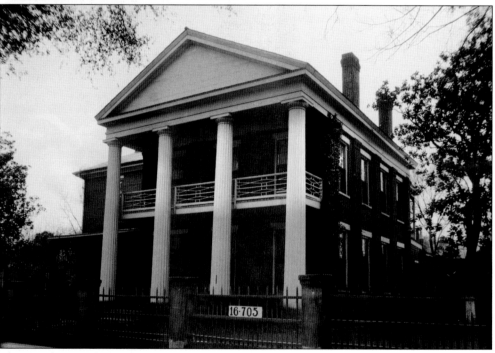

This Greek Revival–style home was built around 1850 by Dr. Albert Gallatin Mabry, a prominent physician and member of the Alabama Legislature. Dr. Mabry was a leader in organizing the Alabama State Medical Association and instrumental in passing legislation that established Bryce Hospital, the state's first hospital for the insane. When Catesby ap Rogers Jones married Dr. Mabry's stepdaughter Gertrude Tartt, they moved back and raised their children in the historic home. Jones's descendants continue to reside in the home today. (LOCDC.)

John Whitfield Lapsley was born in 1806 in Tennessee. Both his grandfathers were officers during the Revolutionary War. He relocated to Selma around 1825 and worked in a mercantile house until he entered law school at age 23. Following graduation, he returned to Selma and entered into partnership with Dr. Daniel Troy, Judge William Byrd, and Gen. John Tyler Morgan. He was prominent in the building of Selma's railroads, was an original stockholder in the Hotel Albert, and he contributed greatly to the rebuilding of the First Presbyterian Church. On August 14, 1865, Lapsley was granted a pardon for his support of the confederacy by Pres. Andrew Johnson. (ADAH.)

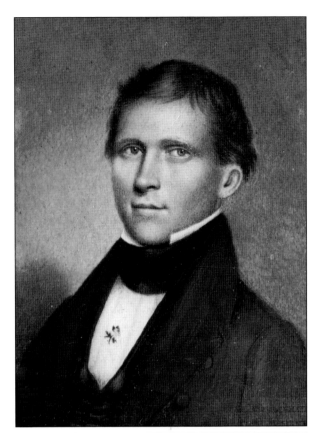

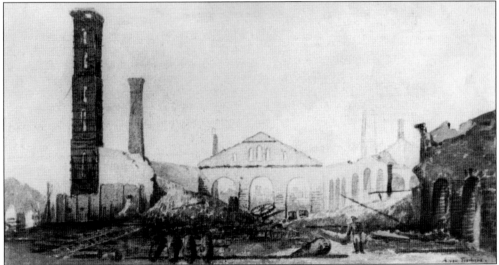

The Selma Naval Foundry and Ironworks (also called the Selma Ordnance and Naval Foundry) and the Selma Arsenal were leading manufacturing centers for the South during the Civil War. The facility, located on the Alabama River, produced finished war materials for the Confederate armed forces from pig-iron ingots at the state's blast furnaces. At its peak, around 1863, the center employed some 10,000 workers in 100 buildings and was second only to the Tredegar Ironworks in Richmond, Virginia, in the production of war materials. (ADAH.)

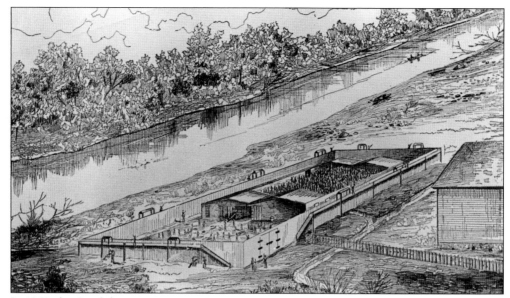

In 1863, the Confederate government began to establish a series of new prisons to accommodate the large number of captured Union soldiers. Cahaba Prison, known as Castle Morgan, was established on a bluff overlooking the Alabama River. As was the case in all Civil War prisons, North and South, conditions were deplorable. The water supply was polluted, and the old warehouse contained only one fireplace. By 1865, the prison, which measured 125 feet by 200 feet, held more than 3,000 men and had only 435 bunks. Despite such conditions, Castle Morgan ranked among the least deadly of the war's military prisons. (BRC.)

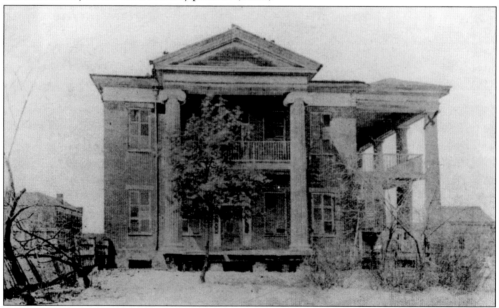

The Old Crocheron House was the site where General Wilson met General Forrest and arranged for the exchange of prisoners after the Battle of Selma. The home was built in 1843 by Richard Crocheron for his new bride. The front porch had a magnificent view of both the Alabama and Cahawba Rivers. When his wife died in 1850, Richard sold his property, freed his slaves, and returned to New York with his children. (BRC.)

James W. Moore was born in Selma in 1852. At the age of 13, Moore enlisted with Morgan's Partisan Rangers, a unit of Wheeler's Cavalry; because of his young age, he was sent home after a year of fighting. During the Battle of Selma, he carried drinking water to the troops. In 1872, Moore graduated from Virginia Military Institute. In the late 1940s, as one of the oldest living Confederate members, Moore was declared honorary commander in chief of the United Confederate Army. (Old Depot Museum.)

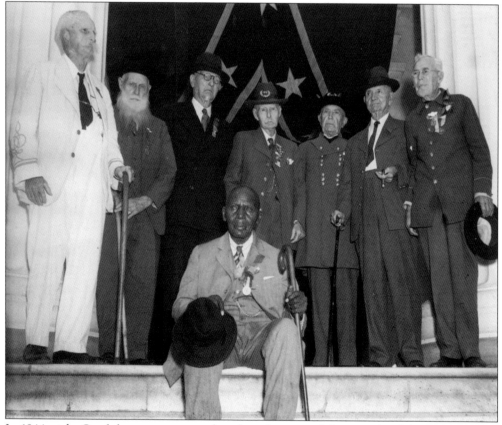

In 1944, eight Confederate veterans gathered on the steps of the capitol in Montgomery while attending the last known Confederate veterans reunion. Standing from left to right are Gen. William Banks; Gen. W. Alexander; Gen. J.D. Ford; Gen. T.H. Dowling; Gen. James W. Moore of Selma; Col. W.H. Culpepper, and Gen. W.M. Buck. Seated in front is Dr. R.A. Gwynne of Birmingham, the only African American to attend the reunion. (ADAH.)

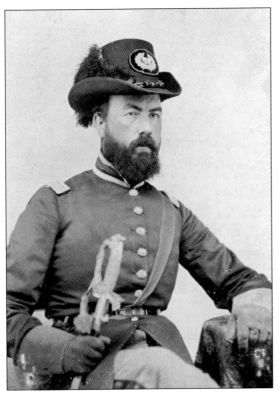

At left, Nathaniel Henry Rhodes Dawson (February 1829–February 1895), following the secession of Alabama, was chosen captain of the "Cadets," which included the Selma Minute Men and the Magnolia Guards. The 4th Alabama Infantry (Company C, Magnolia Cadets) flag, pictured below, was made in Selma, Alabama, by Elodie Todd and Martha Todd White, the half-sisters of First Lady Mary Todd Lincoln. Elodie Todd later married Col. Nathaniel Dawson. The flag was presented to the company in Selma on April 24, 1861, and used for the last time during a dress parade at Harpers Ferry in June 1861. Following his service, Colonel Dawson returned to Alabama with the flag. Over 40 years later, in June 1903, Dawson's son Henry donated the flag to the Alabama Department of Archives and History in the "most excellent condition of preservation." In 1880, Dawson was elected to the state legislature, and later served as US commissioner of education. (ADAH.)

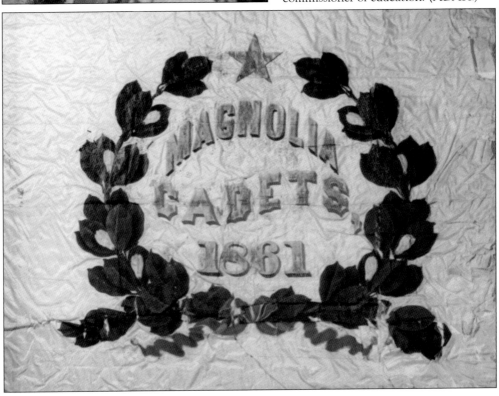

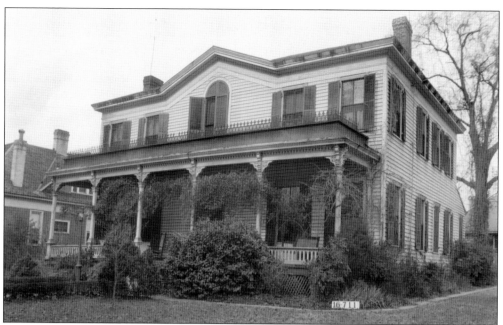

The original wood-frame home seen above, located at 704 Tremont Street, was built in 1842 by E.W. Marks and was the principal residence for Col. Nathaniel Dawson and his wife, Elodie Todd. The two-story home featured intricate ceiling medallions, two marble fireplaces, and a covered porch along the front of the home. In the 1950s, Selma businessman J.B Converse and his wife purchased the home, demolished it, and built a new 5,800-square-feet brick home. Out of respect for neighboring homes, the Converses salvaged and reinstalled the beautiful carved wood doors, two marble fireplaces, the exterior iron-work lanterns, and much of the original wide plank, peg and groove wood flooring in the new home, seen below. Now known as 700 Tremont Street, the home is owned by Dr. David Jackson and Sharon Jackson, the book's author. (LOCDC and author's collection.)

The Wesley Plattenburg House, on the corner of Lapsley Street and J.L. Chestnut Jr. Boulevard, was built in 1842. The house featured a unique combination of Greek Revival and Italianate styles. In the 1820s, Plattenburg relocated to Selma, and by 1829 he had become a successful merchant who served on the Selma City Council for many years. The home was once at the center of a 2,200-acre plantation and is one of only a few structures identifiable on a map of the Battle of Selma. The hole in the column was from Union gunfire. (LOCDC.)

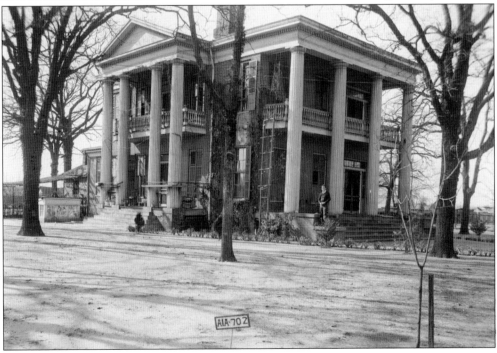

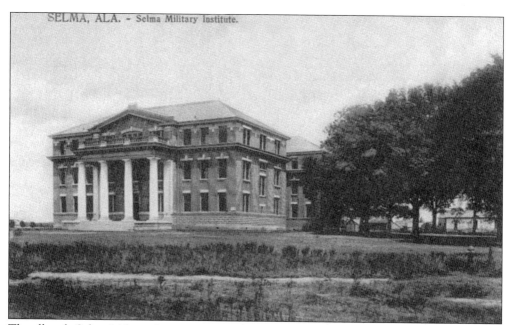

The all-male Selma Military Institute was under the control of the Presbyteries of Tuscaloosa and Mobile. The Presbyteries believed the school could address not only the soul, but the "whole man," and prepare them for future leadership. The institute provided a rigorous academic curriculum for the rich and middle class. In 1904, the school was located in the Old Vaughn Hospital and remained there until the institute pictured above was built at North Broad Street and First Avenue. An unidentified class of cadets shares a minute of down time below. The site has since served as a Methodist children's home and is currently part of Concordia College. (Selma–Dallas County Public Library and BRC.)

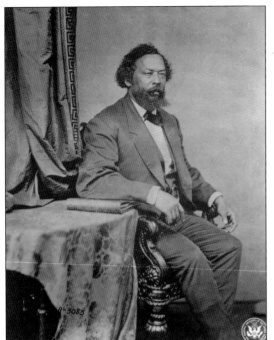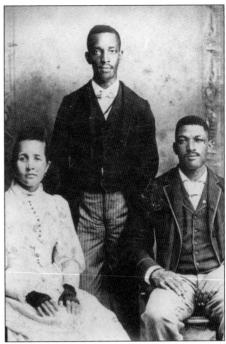

Benjamin Sterling Turner (1825–1894), at left, was born into slavery in North Carolina. He and his brother Henderson were brought to Selma at a young age by their owner, a wealthy widow named Elizabeth Turner. Ben learned to read by stealth at night after being threatened with 500 lashes if he were caught learning to read. After his owner's death, he became the trusted servant of Dr. James Gee, owner of the St. James Hotel. Dr. Gee allowed him to run his own business on the side, from which he acquired $1,600. Turner offered the money to Gee for his freedom, but his master refused the offer. During the Civil War, Dr. Gee entered the Confederate Army and left Turner in full control of his business. The Emancipation Proclamation freed Turner from 40 years of slavery, and due to his business skills he came out of bondage richer than his former master. In 1865, Turner became a teacher and was actively involved in establishing the first school for African American children. In 1867, he was elected the Dallas County's tax collector, and in 1869 he became a Selma councilman and served on the Federal Grand Jury. An astute businessman, the 1870 census listed Turner's assets as $2,150 in real estate and $10,000 in personal property. This fact ranked him as one of Alabama's wealthiest freedmen. During Reconstruction, Turner was elected to represent Alabama in the 42nd Congress. He was Alabama's first African American congressman and the second to serve in the US House. The Todd Family, at right, are descendants of Benjamin and his wife, Ella Todd. (LOCDC.)

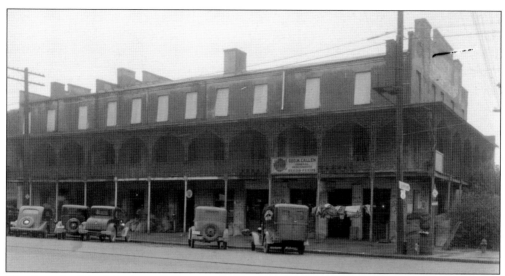

The Brantley Hotel, built in 1837, was named after Brig. Gen. John Brantley, who helped fund the construction. The lower floors housed offices, a bar, billiard room, and several stores. The spacious parlor was on the second floor, with a ballroom on the top floor and 25 guest rooms. In 1948, Maj. John Mitchell took over and reamed it Planters Hotel. Located in the hotel's courtyard was the largest mineral well in the city, offering 100 gallons a minute, and it supplied water to the hotel and was believed to have healing powers. The hotel was remodeled again in 1860 and renamed the Troupe House. Under Dr. James Gee, it was renamed the St. James. In 1865, the Union Army seized the city and set up its headquarters in the hotel. After the war, it flourished until the completion of the Hotel Albert. Reportedly, outlaw Jesse James visited his mistress Miss Lucinda at the hotel on numerous occasions. The establishment finally closed in 1893, and the building served a number of commercial and industrial uses, including a feed store and tire-recapping factory. The original exterior walls, balconies, and the upper floors were only minimally changed when the hotel came into the city's possession. In 1997, the City of Selma, a group of prominent investors, and local citizens restored the hotel back to its original grandeur and reopened it to the public. Today, the St. James Hotel is the only existing antebellum riverfront hotel in the Southeast. (LOCDC.)

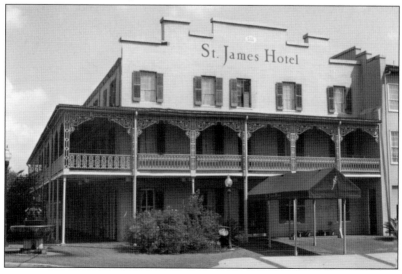

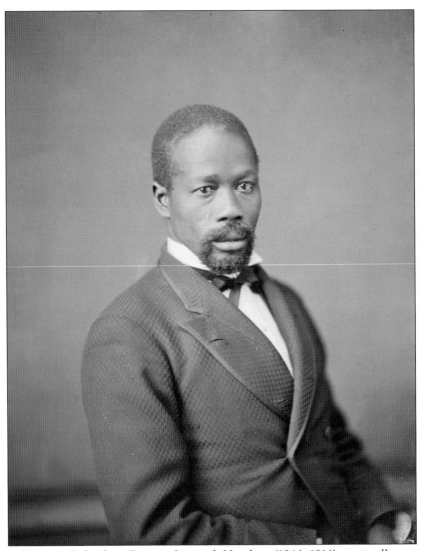

Born into slavery in Columbus, Georgia, Jeremiah Haralson (1846–1916) eventually rose to serve in the US House of Representatives from Alabama's 1st Congressional District in the 44th US Congress (1875). Haralson was the first black member of the Alabama House of Representatives, in 1870, and a state senator, in 1872. Born on the plantation of John Walker near Columbus, Georgia, Haralson was raised as a slave. He was sold on the auction block in Columbus to J.W. Thompson. When Thompson died, Haralson became the property of Judge Jonathan Haralson of Selma, Alabama. He remained Haralson's slave until 1865. While enslaved, he was self-educated and identified as a preacher. As a member of congress, Jeremiah sought for general amnesty for former Confederates to help create harmony between blacks and whites. His oratorical abilities drew the commendation of Frederick Douglass, who called him "one of the most amusing, ready-witted, gifted debaters" he had ever heard. In 1879, Haralson was appointed by Pres. Rutherford B. Hayes to a federal position in the US Custom House in Baltimore, Maryland. He was later employed as a clerk at the Department of the Interior and was appointed on August 12, 1882, to the Pension Bureau in Washington, DC; he resigned on August 21, 1884. (LOCDC.)

John Tyler Morgan moved to Alabama as a young boy. At the age of 20, without having attended college, Morgan passed the bar, having studied at a private law school in Tuskegee operated by his brother-in-law, Alabama chief justice William Parish Chilton. Morgan enlisted as a private in the Confederate army in 1861, rising through the ranks to become brigadier general two years later. Following the war, he returned to his law practice and was elected to the US Senate in 1876. He distinguished himself as a member of the Foreign Relations Committee, as the ranking minority member for 22 years and chairman from 1893 to 1895. Morgan argued tirelessly for construction of the Panama Canal and for increasing America's territorial holdings. As one of the most outspoken white supremacists of the early Jim Crow era, he vigorously championed the policies of black disfranchisement and racial segregation. He served in the Senate from March 4, 1877, until his death in 1907. (ADAH.)

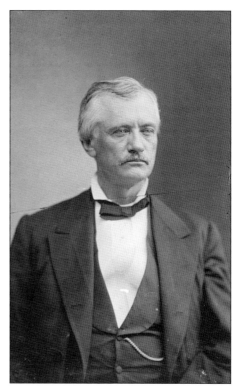

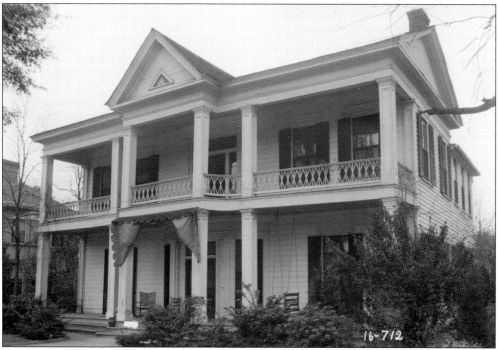

The John Tyler Morgan House, at 709 Tremont Street, was built in 1859 in the Classical Revival style. Senator Morgan used the home as his primary residence from 1865 to 1907. In 1965, the home served as the initial location for the John Tyler Morgan Academy. (LOCDC.)

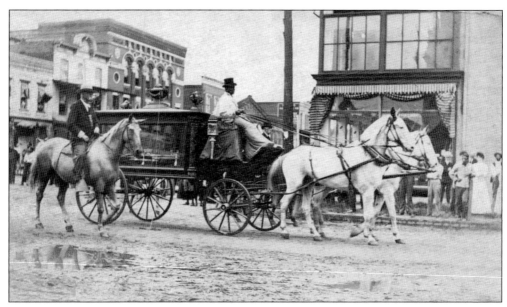

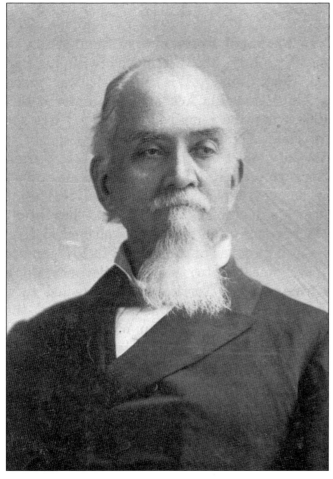

Edmund Winston Pettus (July 1821–July 1907), a distant cousin of Jefferson Davis, was a lawyer, soldier, and legislator. Pettus served in the Mexican–American War from 1847 to 1849, and was a delegate to the secession convention in Mississippi, where his brother John was serving as governor. Pettus helped organize the 20th Alabama Infantry. After the war, Pettus resumed his law practice in Selma, where, standing at six feet tall and having a deep voice, he was an impressive figure. In 1877, he led the Ku Klux Klan as grand dragon of the Realm of Alabama. On March 4, 1897, he was elected to the US Senate and served until his death in 1907. He was the last Confederate brigadier general from Alabama to serve in the US Senate. Senator Pettus's funeral procession, pictured above, travelled through downtown Selma, up Broad Street, and along Alabama Avenue. (ADAH and Old Depot Museum.)

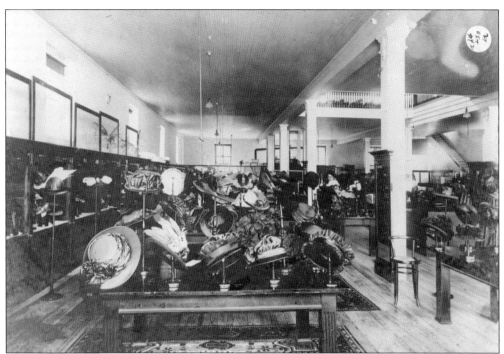

The Jewish presence in Selma dates back to the 1830s, when settlers arrived from the West Indies and later from Western Europe (mostly from Germany). These immigrants first came to Selma and Dallas County as traveling merchants and soon established large wholesale and retail stores. Through World War II, downtown Selma was dominated by Jewish merchants. Broad Street stores included Lilienthal Mercantile, Tepper's, Kayser's, Rothschild's, and others. Two popular restaurants, the Del and the Open Door, were owned by Jewish families. Located off Broad Street were Eagle's, Barton's, Bendersky's, and the Boston Bargain retail businesses. Along Water Avenue were Adler Furniture, Siegel Automobile Co., and a tobacco company. Other businesses included Bloch Brothers Hardware, Hohenberg Cotton, American Candy, and Lewis Cigar Company. Sam Zemurray started with a fruit stand on Washington Street and became president/owner of United Fruit Company, the largest importer of its kind. Pictured here are beautiful hats on sale from Lilienthal's, at 917 Broad Street, and Grace Williams Thomlinson modeling the latest in millinery fashion in 1919. (BRC and Phillips/Williams family.)

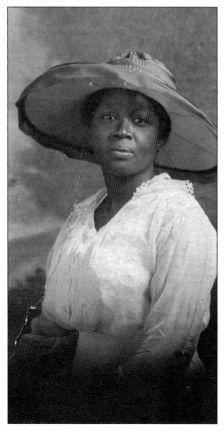

Joseph Seligman (left) immigrated to the United States from Bavaria in 1837 at the age of 17. Through hard work, he became a successful merchant in Selma, which allowed him to accumulate enough money to send for his seven brothers. The Seligmans expanded to New York in the late 1840s and capitalized on the skills and success they had garnered in Selma. Together, the brothers created J. & W. Seligman and Company, which grew into an international banking firm and import and merchandising enterprise with offices in New York, San Francisco, and Europe. Joseph became a close friend of both President Lincoln and President Grant and was called on by Lincoln to raise money in England for the Union. Following the war, the Seligmans were involved in financing several major US railroads, construction of the Panama Canal, and the formation of Standard Oil and General Motors. President Ulysses S. Grant offered Joseph the position of secretary of treasury, which he declined. Selma's proud Jewish community has produced three mayors: Simon Maas (right), 1887–1889; Marcus J. Meyer, 1895–1899; and Louis Benish, 1915–1920. Others who have served have been city council presidents and councilmen and on the Selma School Board. Seven presidents of the chamber of commerce have been Jewish. (Selma–Dallas County Library and City of Selma.)

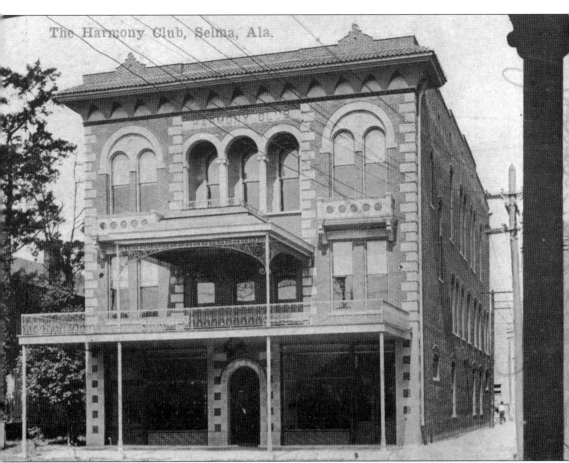

The Harmony Club, Selma, Ala.

Founded in 1867, the Harmony Club served as a social hub for the Jewish community, hosting dances, card games, billiards, and other social functions. In 1909, the club erected a three-story brick building on Water Avenue. The project was headed by Benjamin J. Schuster, owner of Schuster Hardware Company. The first floor had two retail spaces, and the second floor housed a restaurant up front and a private men's lounge in back. The lounge had a pool table, poker games, slot machines, and a cigar room; of course, wives were not allowed, but occasionally "ladies" were. The third floor was a ballroom that hosted lots of dances and parties over the decades. The Elks Club assumed responsibility for the club from the late 1930s until it was boarded up in 1960. The building sat dormant for 40 years until David Hurlbut bought it in 1999 and started a total renovation. The Harmony Club is listed in the National Register of Historic Places and continues to be a work in progress. (Selma–Dallas County Public Library.)

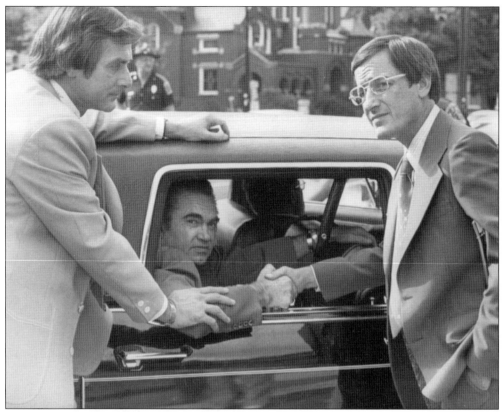

Pictured above are Mayor Joe Smitherman (left), Gov. George Wallace (center), and Cecil Jackson Jr. Joseph T. "Joe" Smitherman (December 1929–September 2005) worked as a railroad brakeman before joining the US Army during the Korean War. Upon being discharged, he opened the Home Appliance Company in Selma. In 1960, he won a seat on the Selma City Council and was elected mayor in 1964. Smitherman served as mayor for almost 35 years. During his tenure, Selma experienced tumultuous times with the struggle for voting rights, Bloody Sunday, and the closure of Craig Air Force Base. "I fought change, and all the while I was for it," said Smitherman in the *Selma Times-Journal* in September 2005. "A political stance is often different from your personal beliefs." Smitherman was defeated in 2000 by James Perkins Jr., at left, who had challenged him two times previously. (Smitherman Vaughn Museum.)

Three

STRUGGLES FOR EQUALITY

"This woman, after walking 40 miles, told me that her feet were tired, but her soul was rested. She was asleep camped on the side of the road after a day of marching, my flash didn't wake her," said Spider Martin, the famed civil rights photographer. (James "Spider" Martin.)

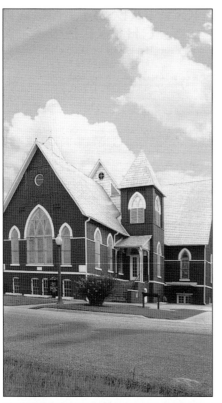

Before 1866, black and white Baptists worshipped together, and there was only one First Baptist Church. After the Civil War, African American deacon Alex Goldsby and a group of other freedmen asked permission from Pastor J.B. Hathorne to open Selma's first school for black youth in the church basement. The church later contributed $2,000 to help them start their own church on St. Phillips Street. The Reverend John Blevins was the first pastor, and in 1866 the church membership was approximately 800. Selma University was started in the basement of First Baptist on January 1, 1878. In 1894, under the leadership of Pastor C.J. Hardy, a new building was erected on Sylvan Street (now Martin Luther King Jr. Street), and David West served as the architect. During the voting rights movement of the 1960s, First Baptist hosted the youth rallies, and meals were prepared for the busloads of people, including college students, who came carrying sleeping bags and knapsacks to participate in the Selma-to-Montgomery march. On May 1, 1978, a tornado struck First Baptist, tearing off much of the roof; the restored church reopened on December 5, 1982, and has been declared a national historic site. (Madden & Associates and BRC.)

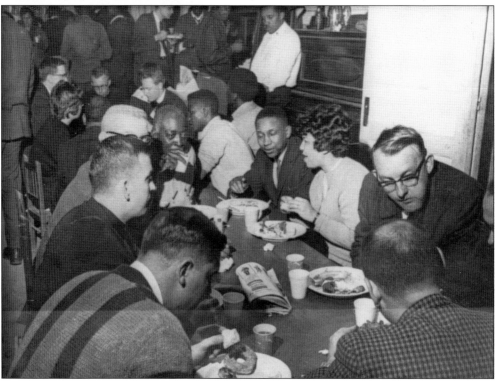

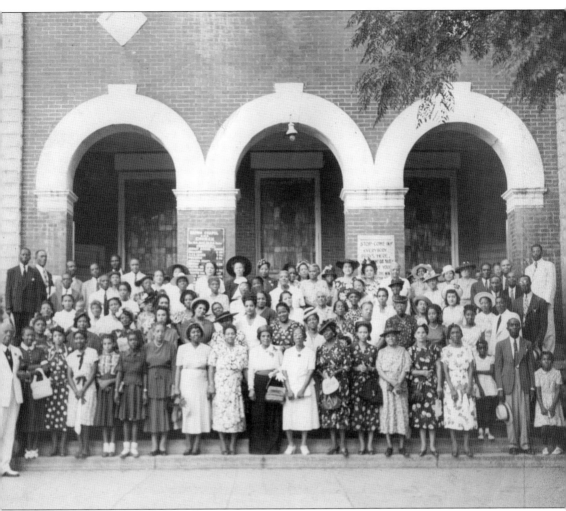

Before Emancipation, Selma's African American Methodists worshipped with their masters at Church Street Methodist Church. After they were freed, they began meeting separately, at private homes and in the basement of the Hotel Albert. On August 31, 1867, missionary John Turner addressed a group meeting and asked those present to stand up if they wished to unite themselves with the African Methodist Episcopal connection; the congregation stood up as one. In 1869, the new congregation bought a plot of land on Sylvan Street (now Martin Luther King Jr. Street) and built a church there, which they named Brown Chapel in honor of Bishop John Mifflin Brown. In 1908, the congregation contracted architect A.J. Farley to build an imposing Romanesque structure with Byzantine and Mission-style influences. Perhaps Brown Chapel's greatest moments in the spotlight came in 1965, when it served as the meeting place for the voting rights movement and the starting point for the Selma to Montgomery marches. In defiance of Judge James Hare's injunction banning mass meetings, Pastor P.H. Lewis opened the doors of Brown Chapel to the voting rights movement, and thousands attended the weekly rallies. (Phillips/Williams family.)

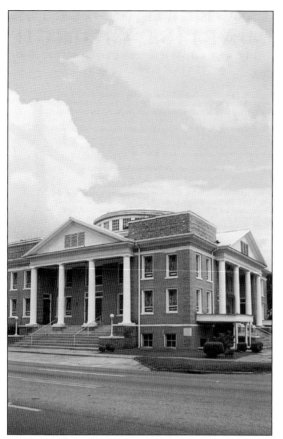

When Rev. Edward W. Brawley became president of the Alabama Baptist Normal and Theological School (now Selma University) in 1884, he decided that the students and faculty needed their own church. In January 1885, several members of First Baptist MLK joined him in establishing a new congregation, which met in the university's chapel. On July 5, the congregation incorporated as Tabernacle Baptist Church. A small building was erected on Minter Avenue next to the present structure, and in 1922 a new two-story building was erected. Constructed in a complex symmetrical plan, the sanctuary features a gabled roof and a dome encircled by a clerestory. David West, a church deacon, served as architect. The pastor, Rev. Lewis L. Anderson, and his wife, Pauline Dinkins, were pioneers of the civil rights movement, and Tabernacle was the first church to open its door for mass voting rights meetings. In 2014, Tabernacle was added to the Alabama Register of Landmarks and Heritage. Pictured below are deacons and church officers in 1948. (Madden & Associates and ADAH.)

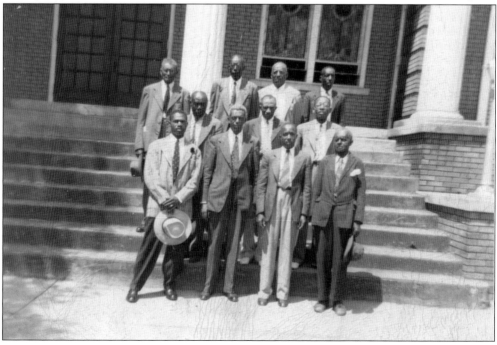

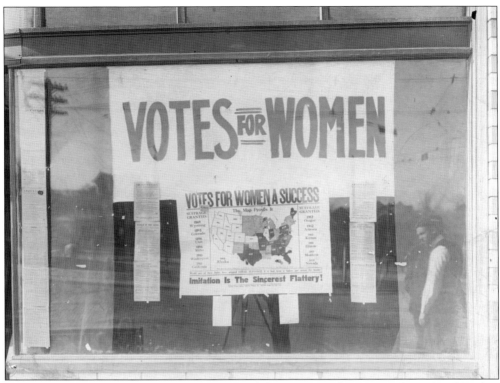

The women's suffrage movement was reborn in Alabama on March 29, 1910, when Mary Winslow Partridge called a group of ladies together at Selma's Carnegie Library to found the Alabama Equal Suffrage Association (ESA). The original members included Amiee DuBose, wife of Dr. DuBose; Mary Watson, daughter of Mayor J.R. John; Mary Howard Raiford, manager of the *Selma Times Journal*; Hattie Hooker Wilkins; and Julie Partridge Hatch. By 1913, chapters of the Alabama Equal Suffrage Association had sprung up around the state (several founded by Julie Partridge), and the first statewide convention was held at Selma's Hotel Albert. In 1916, Selma's Carrie McCord Parke (1862–1939), daughter of one of Selma's pioneer families, was elected president. (ADAH.)

Nellie V. Baker, a Selma native, headed the Alabama Association Opposed to Women Suffrage. Baker, one of the richest women in Selma, was also an organizer and regent of the Selma chapter of the Daughters of the American Revolution. Pictured in 1907 are Mary Baker (Parrish), Nellie V., and their father, "Old Baker," in front of the family home at the corner of Dallas Avenue and Lapsley Street. (BRC.)

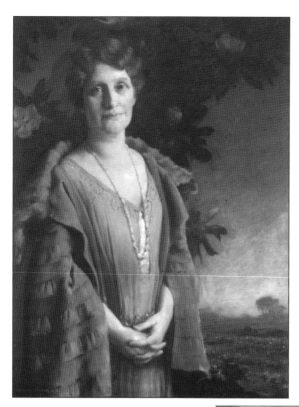

Hattie Hooker Wilkins (1875–1949) was born and raised in Selma. A mother of four, she was a homemaker and primary caregiver to her children. She was a member of the Alabama ESA and helped to found the Selma association. In 1923, she was elected as the first woman to serve in the Alabama Legislature. (Old Depot Museum.)

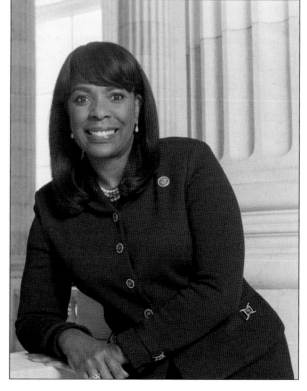

Terrycina Andrea "Terri" Sewell, born January 1965, is a native of Selma and a graduate of Princeton University, Harvard Law School, and Oxford University. Elected to represent Alabama's 7th Congressional District in 2011, she was the first African American woman elected to Congress from Alabama. Congresswoman Sewell and Congresswoman Martha Roby were the first women elected to Congress from Alabama in regular elections.

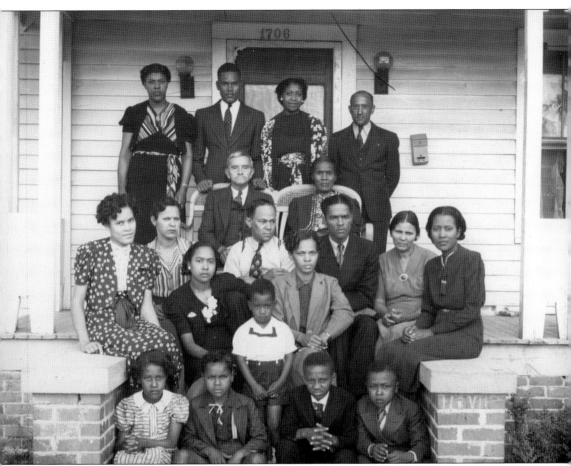

Robert (1861–1940) and Julia Thomas Norris (1879–1958) moved to Selma from the village of Rehoboth in Wilcox County in 1917. Robert was a carpenter and farmer by trade, and Julia, who had been a teacher in a rural school, became a cook when they moved to town. By the 1930s, most of their children had moved to Birmingham, New Orleans, Detroit, or Chicago but returned home often for weddings, funerals, and other family events. This photograph of Robert and Julia surrounded by some of their children and grandchildren was taken on the front porch of 1706 Green Street in 1937. Their daughter, Velma Norris Kimbrough (far right in the dark dress), was the first African American to teach at a white school in Selma. Velma was a graduate of Stillman College and Teachers College, Columbia University. Her husband, James C. Kimbrough (not pictured), a realtor and insurance agent, also made history when he was elected to the Selma City Council in 1972, one of the first five African Americans to serve since Reconstruction. (Brenda Smothers/Norris family.)

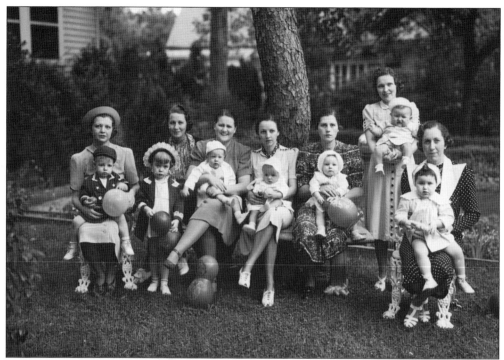

The 1940s, especially the first half of the decade, brought a massive change to the role of women in American society. Females were encouraged to enter the workforce as part of their patriotic duty. When World War II ended, women were expected to give their jobs back to men and return to their traditional roles as housewives and mothers; however, times had changed, and many women found great satisfaction in their newfound skills and had no desire to return to their pre-war status. In the late 1950s and early 1960s, millions of married women entered the workforce. (BRC.)

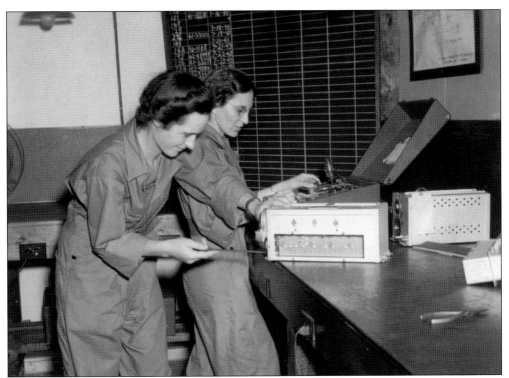

World War II was a pivotal time for women's establishment as an equal part of the workforce. While direct involvement in military operations was limited, women played a decisive role in wartime production, support services, and medicine. As a result of their success, the whole perception of the capabilities of the so-called "weak gender" altered. By the end of the war, the number of employed women had risen to 18 million, one third of the total workforce. (Craig Field Airport and Industrial Complex Authority Archives.)

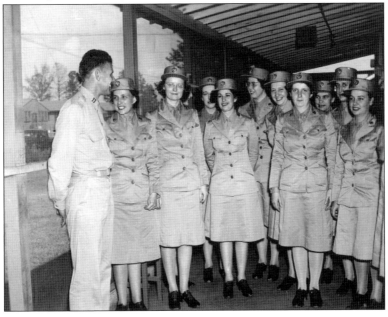

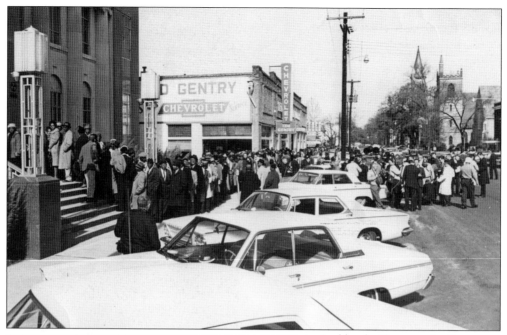

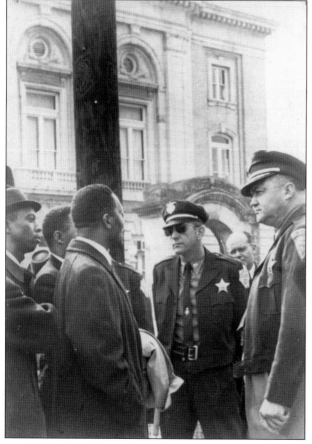

Led by the Boynton family (Amelia, Sam, and son Bruce), Rev. L.L. Anderson, J.L. Chestnut, and Marie Foster, the Dallas County Voters League (DCVL) attempted to register black citizens during the late 1950s and early 1960s. Their efforts were blocked by state and local officials, the White Citizens' Council, and the Ku Klux Klan. The citizens council was founded in Selma with the specific intent was to prevent integration. Throughout 1963 and 1964, against fierce opposition from Dallas County sheriff Jim Clark and his volunteer posse, African Americans continued their voter registration and desegregation efforts. They defied intimidation, economic retaliation, arrests, firings, and beatings. Above, citizens line up at the courthouse hoping to register to vote. At left, Rev. L.L. Anderson of Tabernacle Baptist Church is blocked from registering to vote by Sheriff Jim Clark. (BRC and LOCDC.)

The Dallas County Voters League's "Courageous 8" (Ulysses S. Blackmon Sr., Amelia Boynton, Ernest Doyle, Marie Foster, James Gildersleeve, J.D. Hunter Sr., Dr. F.D. Reese Sr., and Henry Shannon Sr.) extended an invitation to the Reverend Dr. Martin Luther King Jr. and the Southern Christian Leadership Conference (SCLC) to come to Selma and assist them in their voter registration efforts. The Selma voting rights movement officially started on January 2, 1965, when King addressed a mass meeting in Brown Chapel in defiance of the anti-meeting injunction. Over the following weeks, Selma citizens, SCLC, and the Student Nonviolent Coordinating Committee (SNCC) expanded voter registration drives and protests in Selma and the adjacent Black Belt counties. At right, Dr. King speaks at a mass meeting at Brown Chapel with, from top to bottom, Dr. F.D. Reese, Andrew Young, and Sheyann Webb pictured in the foreground. Sheyann and Rachel West, pictured below, were just two of the hundreds of Selma's children and teenagers who actively participated in the fight for voting rights. Sheyann, then age 10, participated in the march on Bloody Sunday, and her involvement in the movement was the basis for the movie *Selma Lord Selma*. (ADAH.)

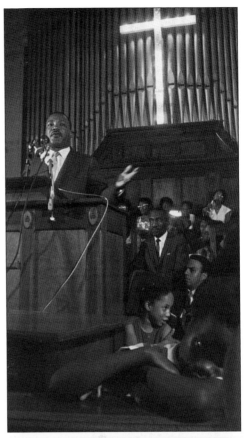

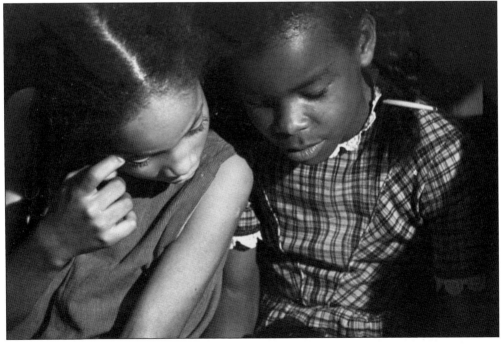

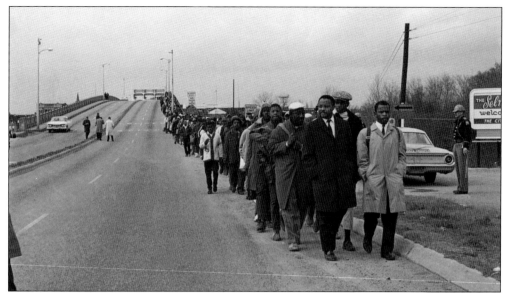

In February 1965, Jimmie Lee Jackson of neighboring Marion, Alabama, was shot and killed by Alabama state trooper James B. Fowler while trying to protect his mother during a nighttime voting rights march. In protest of the shooting, activist Rev. James Bevel called for the mourners to carry Jimmie Lee's casket to Montgomery. On Sunday, March 7, approximately 600 marchers set out from Brown Chapel AME Church east on US Highway 80 and headed for Montgomery to petition the legislature for reforms in the voter registration process. The march was led by, above from left to right, (front row) Rev. Hosea Williams of SCLC and John Lewis of SNCC and (second row) Albert Turner of SCLC and Bob Mants of SNCC. The protest went according to plan until the marchers crossed the Edmund Pettus Bridge, where they found a wall of state troopers waiting for them on the other side. Sheriff Jim Clark had issued an order for all white males in Dallas County over the age of 21 to report to the courthouse that morning to be deputized. (Spider Martin.)

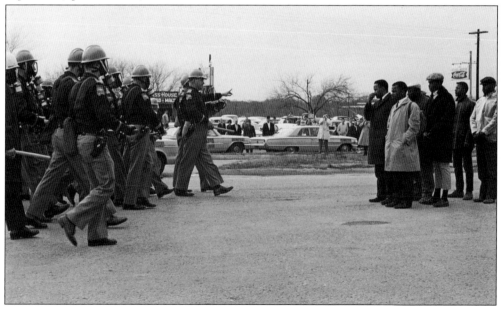

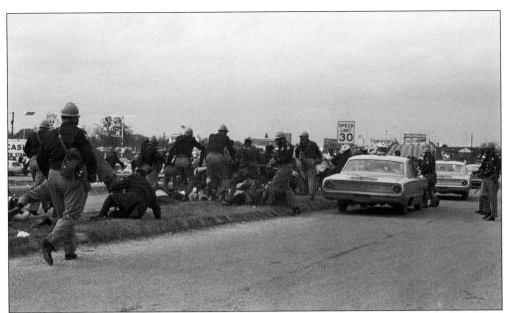

The troopers' commanding officer, John Cloud, told the demonstrators to disband at once and go home. Rev. Hosea Williams tried to speak to the officer, but Cloud curtly informed him there was nothing to discuss. Seconds later, the troopers began shoving the demonstrators. Many were knocked to the ground and beaten with nightsticks. Another detachment of troopers fired tear gas, and mounted troopers charged the crowd on horseback, attacking and severely injuring many marchers. Amelia Boynton and others were left beaten, gassed, and unconscious along the highway. A total of 17 marchers were hospitalized at Good Samaritan Hospital and hundreds were treated back at Brown Chapel. Below, Margaret Moore, an educator and activist, leans against a pole in shock following the attack. The national press soon began calling the day Bloody Sunday. (Spider Martin and the Moore family.)

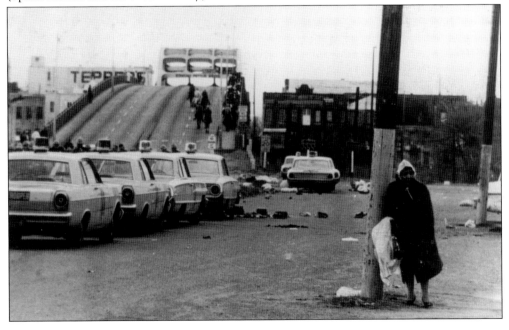

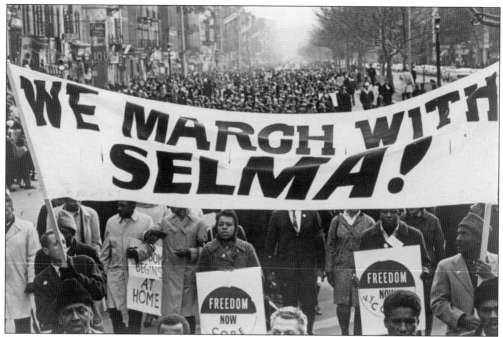

Immediately following the tragic events of Bloody Sunday, Dr. King Jr. issued a nationwide call for "people of conscience to stand with local blacks in the struggle for voting rights." Thousands of marchers took to the streets of Harlem, New York, in a show of support for Selma. For many Americans who had never before marched or never before protested, Bloody Sunday was the tipping point that moved them into action. Students, clergy, housewives, and men and women from all walks of life, all different races, chose to take a stand. Some hit the road for Selma, some protested locally, and some demanded immediate action from their US senators and representatives. Selma moderates, such as Charles W. Hohenberg, a cotton broker and civic leader, tried to head off a racial confrontation in Selma, but to no avail. Three ministers were walking back after dinner to a meeting led by Dr. King when they were attacked by a group of white men. One hit Rev. James Reeb in the head with a club. The blow was fatal, and Reverend Reeb died on March 11. He is recognized as the second martyr of the Selma voting rights movement. (BRC and ADAH.)

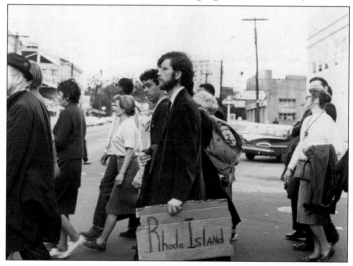

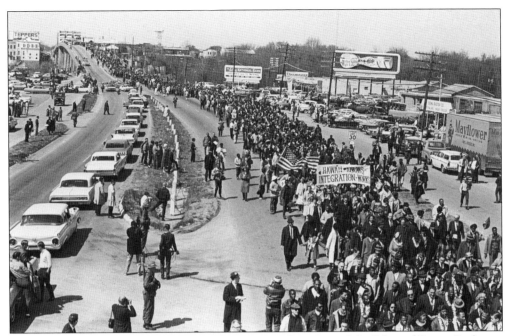

On Sunday March 21, 1965, approximately 3,200 marchers crossed the Edmund Pettus Bridge on their way to Montgomery, under the full protection of the US Army and the Alabama National Guard. Almost 1,000 white people, mostly clergy, participated. They walked 12 miles per day and slept in nearby fields. Along the way, celebrities such as Joan Baez (pictured below, at left, with Susan Tomalin, a student at Catholic University, who later became actress Susan Sarandon), Harry Belafonte, Tony Bennett, Sammy Davis Jr., and Peter, Paul, and Mary joined in the march. By the time they reached the capitol four days later on March 25, their strength had swelled to around 25,000 people. Dr. King delivered his rousing speech "How Long, Not Long" at the capitol rally. Later that evening, Detroit housewife and mother Viola Liuzzo, who had come to Selma to support the marchers, was shot and killed by Ku Klux Klan members while ferrying marchers back from Montgomery. She was the third person killed in the Selma fight for voting rights. (Spider Martin and ADAH.)

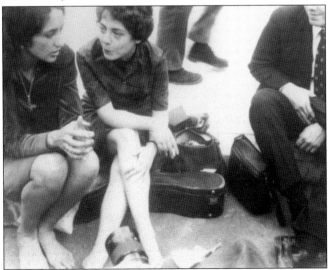

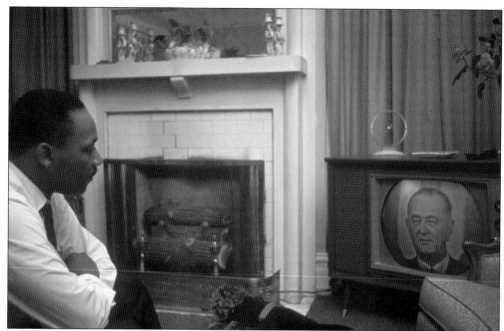

The events in Selma helped increase public support for the voting rights efforts, and on March 15, 1965, Pres. Lyndon Johnson addressed the nation. Millions of households throughout America gathered in front of their television sets to watch President Johnson declare his support for equal voting rights for all citizens. Dr. King and others gathered in the home of Selma residents Dr. Sullivan and Richie Jean Jackson on Lapsley Street to watch the speech. According to Mrs. Jackson, "Dr. King cried when President Johnson concluded his speech with the words, 'We shall overcome.' " Richie Jean was a childhood friend of King's wife, Coretta Scott King, who had grown up in the nearby town of Marion, and Dr. King had set up an informal headquarters at the Jackson home. Congress signed the Voting Rights Act of 1965 into law on August 6. On August 10, 1965, Jonathan Daniels, a 26-year-old white Episcopal seminarian and voting rights activist, was shot and killed in Lowndes County. (Mrs. Richie Jean Jackson and Sharon Jackson.)

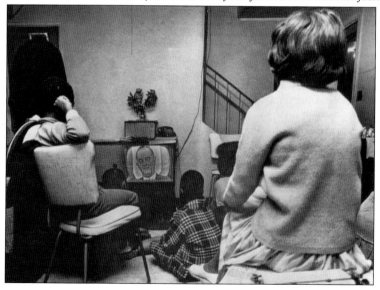

Four

A THRIVING ECONOMY AND VIBRANT DOWNTOWN

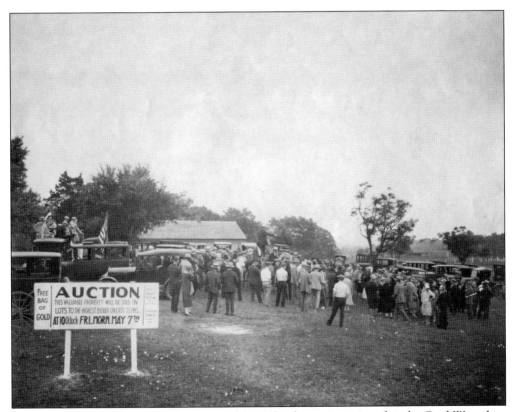

Like most areas of the state, Selma emerged from the depression years after the Civil War when cotton prices began to rise in the early 20th century. In the first decade of the 20th century, Selma's population grew by 56 percent, increasing from 8,713 in 1900 to 13,649 in 1910. (BRC.)

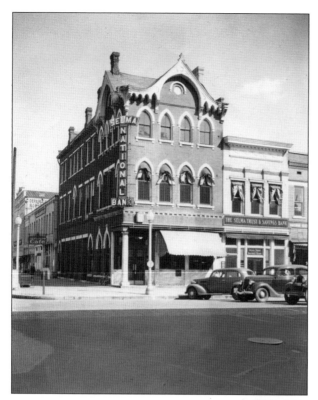

The Selma National Bank was organized on December 15, 1903. Its primary focus was handling personal accounts and real estate loans. In 1923, Selma National became Selma Trust and Savings, and then it was First Alabama Bank, and later Regions Bank. One of the past presidents of the bank included Roger ap C. Jones (1960–1984), the great grandson of Civil War captain Catesby ap Roger Jones. Roger's son Catesby ap Rogers Jones followed in his footsteps and went onto become president of Regions Bank and co-founder of First Cahawba Bank in 2007. (BRC.)

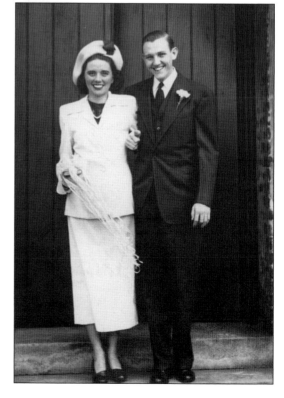

Roger ap C. Jones entered the family banking business as a part-time runner in 1937. After graduating in 1940 with the first class of Albert G. Parrish High School, Jones worked in several areas of the bank, including managing the bank's facility at Craig Air Force Base. In 1960, Jones was named president, remaining there until his retirement in 1984. Roger is pictured with his bride, Edris Donovan, on their wedding day. (Jones family.)

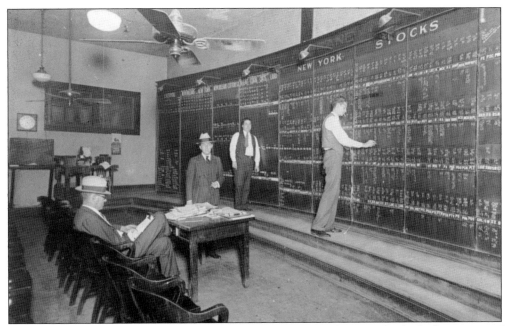

Fenner and Beane Stock Brokerage was located at 1205 Water Street. Grady Ezell, a native of Selma (wearing the dark vest), is marking prices on the blackboard on February 26, 1932. The latest stock quotes were sent by Morse code from New York. Note the telegraph sounders mounted on top of the blackboard. (BRC.)

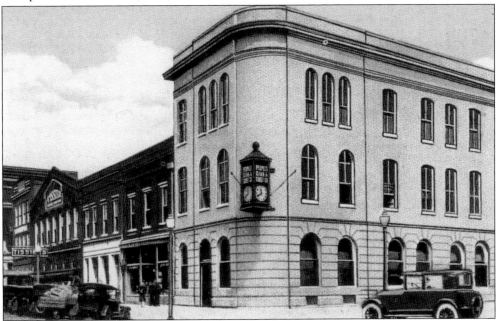

The Peoples Bank & Trust Company was established on August 6, 1902. It was the first bank in central Alabama to accept deposits $1 and up and pay interest on such deposits. Originally named Peoples Savings Bank, its officers included C.M. Howard, S.A. Fowlkes, J.H. Rogers, and A. Urquhart. Located on the corner of Broad Street and Water Avenue, the site is now the location of the Selma–Dallas County Public Library.)

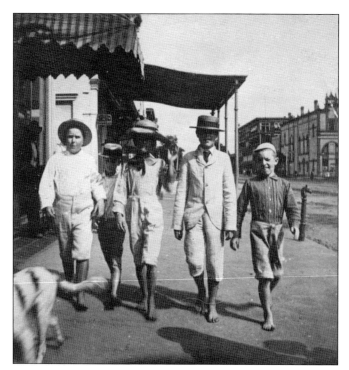

Samuel F. Hobbs (far left) and friends are seen strolling down Broad Street around 1897. They are heading south and have just crossed the alley that ran between Kress and the Hobbs Jewelry store. The Academy of Music and Hotel Albert are on the right. Sam Hobbs would later serve Alabama in Congress and was appointed judge of the 4th Judicial Circuit of Alabama in 1921. (Old Depot Museum.)

City National Bank, founded on January 1, 1870, was the fifth bank established in Selma. The bank's officers were W. P. Armstrong as president and Walter Love as its cashier. (Selma–Dallas County Public Library.)

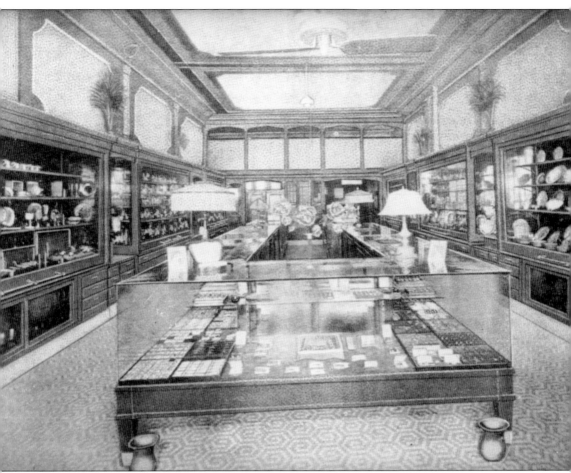

The business known today as Butler Truax Jewelers was founded in 1859 and has seen seven owner changes, nine name changes, and four moves in a one-block radius. Originally owned by Boston brothers G.L. and J.R. Poor, the store was sold in 1859 to Samuel Hobbs and renamed S.F. Hobbs Jewelers. During the Civil War, Sam fought for the Confederacy, and his seven brothers fought for the Union. To protect the store's assets, Sam's wife, Frances, put all of the silver into a sack, removed pieces of the clapboards, and dropped the sack into the wall. Clocks were hidden in the barn between cotton bales, while the store's diamonds, watches, and jewelry were sewn into her petticoat, which she wore day and night. After the war, the store became the Southern wholesale agent for Patek Phillipe Swiss watches and sold Knabe and Steinway pianos. Hit hard by the Great Depression, the store was downsized and moved around the corner to Alabama Avenue. Roger Butler assumed control of the store in 1963 and moved it back onto Broad Street in 1978. Today, known as Butler Truax Jewelers, the store is operated by Roger's daughter Doris Butler Truax and her husband, Jim Truax. (Butler Truax.)

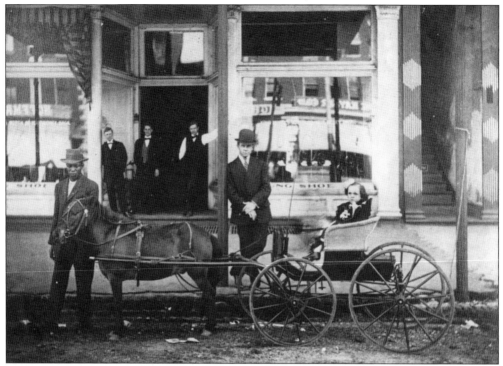

In the 1920s, the Young Shoe Company, at 914 Broad Street next to Kress, gave this pony and buggy away in a promotional campaign. The young lady in the seat was the winner. Mote Peterson is the man in the derby. (BRC.)

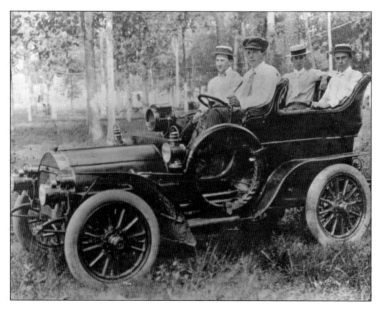

In 1904, Joe Lamar was the first Selmian to own a four-passenger car. The Ford Model B was an upscale touring car with polished wood and brass trim. It was Ford's first car to use the front-engine layout and cost $2,000, the equivalent of $52,000 today. Riding with Lamar are, from left to right, friends Sheren Breslin, Will McKee, and Smith Robbins. (BRC.)

Born into slavery in Dallas County, Will Wages worked at the Old Depot from World War I through World War II. Following his marriage to Della, also born into slavery in Coffee County, the couple relocated to the Selmont area in 1922. Together they owned and operated a five-acre farm, where they grew and raised all of the foods that they consumed. Della put her homegrown wares to good use and was known as a great cook throughout Selma. She was an active woman who remained in excellent health until her passing at 116 years of age. According to her granddaughter Dorothy Jackson Brown, she passed away "simply from old age." (Dorothy Jackson Brown family.)

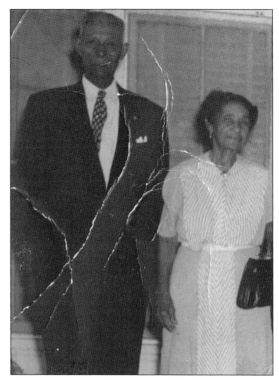

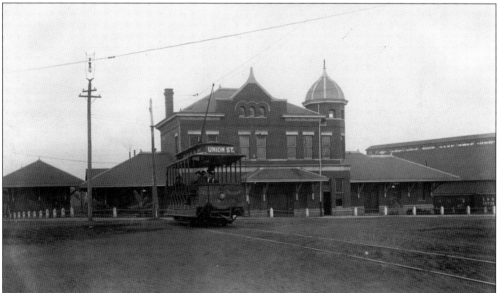

During the height of railroad travel, Selma had two depots. The Southern Railway depot, located on Broad Street north of J.L. Chestnut Jr. Boulevard, and the Louisville and Nashville Railroad, at Water Avenue and Martin Luther King Jr. Street. Today, the L&N Railroad depot houses the Old Depot Museum, which focuses on the history and heritage of Selma and Dallas County. The depot building is one of 12 railroad depots of architectural importance in the Southeast. The first automobile appeared in Selma in 1901 and sparked a decline in rail travel in and out of Selma. (ADAH.)

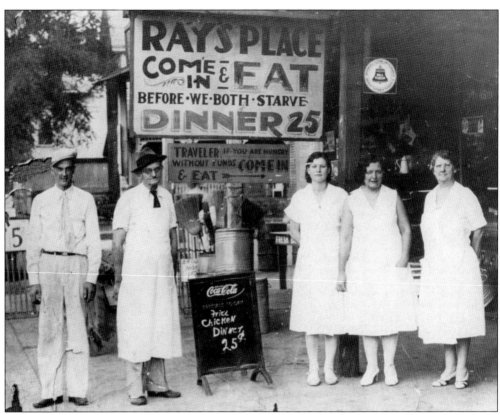

Downtown was the place to get a good meal and reconnect with friends. Restaurant owners prided themselves on giving their customers excellent service and fair prices. The Selma Del and Tim's Café were favorites of locals. Ray's Place, another favorite, offered a complete fried chicken dinner for just 25¢. Note the sign that states, "Traveler if you are hungry and without funds come in and eat." (BRC.)

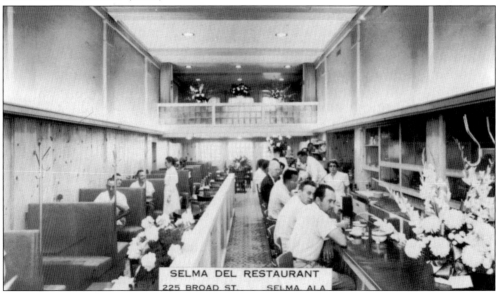

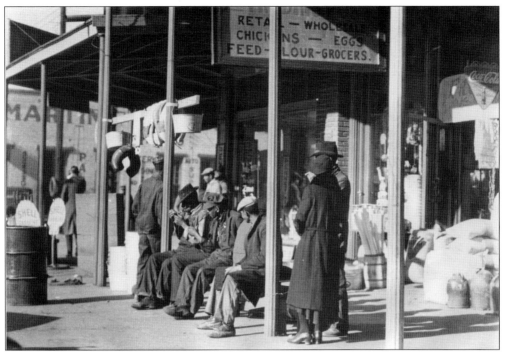

From its earliest days, downtown Selma was an economic hub, offering a wide array of goods and services. In 1817, city founder Thomas Moore set up a trading post at the corner of Green Street and Water Avenue. Following the Civil War, Selma quickly began to rebuild its downtown. In later years, downtown was a place to check out the best cattle and spend a leisurely day with friends on Water Avenue shopping for diamonds, shoes, saddles, or just groceries. (BRC.)

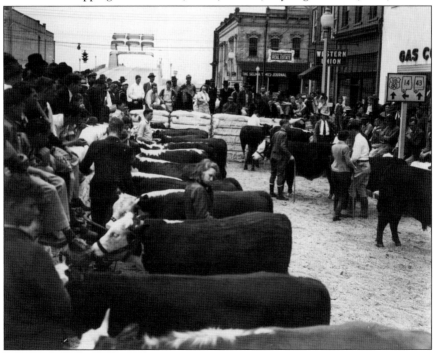

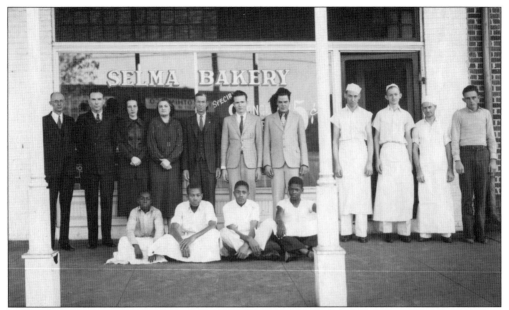

The Selma Bakery was established around 1905 by F.N. Schiel, who prided himself on the "absolute cleanliness of every part of his establishment." Located in the YMCA building, it produced thousands of loaves of bread, cakes pies, cookies, and other goods each day. Handling the daily load required three delivery wagons and five counter employees. (BRC.)

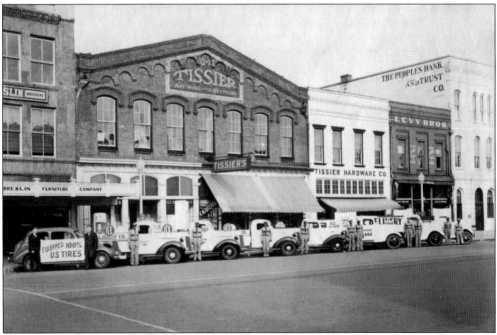

Tissier Hardware was established by Charles G. Tissier in 1885 and had reported annual sales exceeding $300,000. Located at the corner of Broad Street and Hinton Alley, it extended all the way back to Washington Street. The store's inventory included hardware, guns, baseball goods, musical instruments, appliances, glassware, saddles, and other items, and it also installed tires on vehicles. Tissier personally managed the store for over 26 years (BRC.)

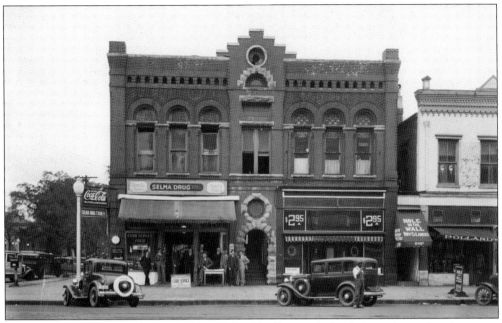

Selma Drug, seen here in the 1920s, was operated by George A. Swift. It was located at the corner of Broad Street and Selma Avenue, known as "the corner where the cars meet." Many of the medicines provided were carefully assembled on site by "expert chemist and perscriptionist." Swift prided himself on quick delivery service, and special care was given to patients of Drs. DuBose, Ward, and Chisolm. It also sold dry goods and women's personal necessities, and it had a large a soda fountain. (BRC.)

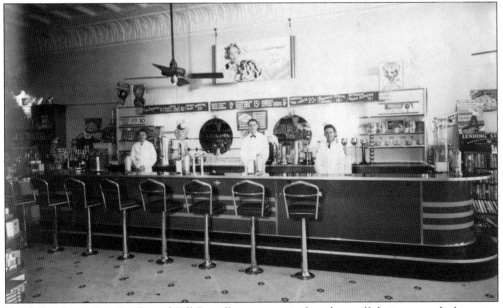

Frank Stephens, Cap Swift, and Bill Broadhers are excited to show off their new soda fountain. Money was so tight in the 1930s that the only way they could afford the new fountain was to have it installed by an ice cream company and pay for it with a 10¢ extra charge on each gallon of ice cream until it was paid off. (BRC.)

The early 20th century brought an expansion in the number of African American businessmen and professionals in Selma as they responded to opportunities to provide services to their own people. The establishment of the Alabama Penny Savings Bank branch in Selma in 1911 was indicative of the growing wealth in the community. John Henry Williams started J.H. Williams and Sons Funeral Home in 1905 on Franklin Street. Now located on Minter Avenue, the funeral home is the oldest African American business in Selma. Calvin Osborn ran the Interlink Cotton Gin Company. Horace Sullivan, an undertaker, and his son H. Stanley Sullivan, a dentist, invested in the construction of the Sullivan Building on the corner of Franklin Street and Alabama Avenue. This brick building soon anchored other African American professionals. By mid-century, the building was home to insurance agents and Dallas County Voters League leaders Samuel Boynton and his wife, Amelia. Pictured at left is a Williams family member standing in front of the Franklin Street office, and Grace (Williams) Thomlinson, the funeral home manager from 1934 to 1952, is seated below in her office. (Williams/Phillips family.)

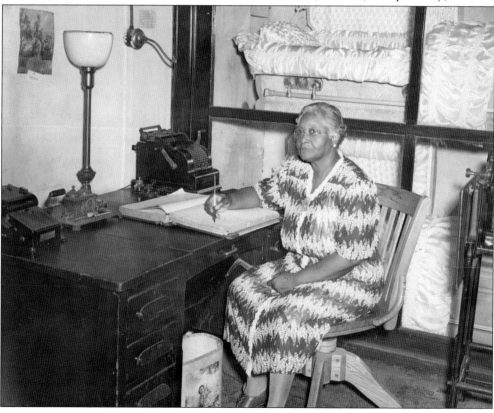

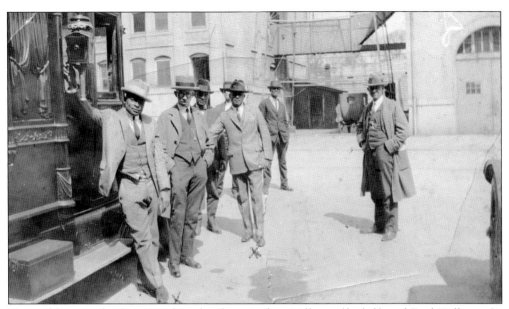

Pictured here in the foreground are brothers Arthur Williams (far left) and Fred Williams Sr. (second from right), of J.H. Williams and Sons, in 1922 on Franklin Street across from city hall. They are standing next to their Cunningham double-decker funeral car. The stylish Cunningham hearse was introduced at the New Orleans Cotton Exposition of 1884, and it revolutionized the styling of the American hearse and birthed the term "funeral car." (Phillip/Williams family.)

Harvey Jackson Sr., a Selma native and tailor, operated O.K. Dry Cleaners, at 108 Washington Street, for 40-plus years. O.K. Cleaners handled the dry-cleaning for Craig Field during World War II. After the passing of Jackson's wife, he raised his eight children in the family's large craftsmen-style home at 1401 Washington Street. (Dorothy Jackson Brown family.)

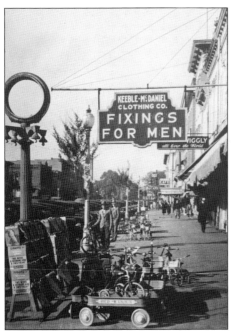

This image, taken in December 1935, shows the Keeble-McDaniel Clothing Co., which was opened in 1913 by Ed Keeble, E.M. McDaniel, and Gordon McDaniel. The store specialized in "fixings for men" and was still in full swing when this photograph was taken. Shoppers could also purchase the Red Injun Wagon, tricycles, newspapers, and magazines. (BRC.)

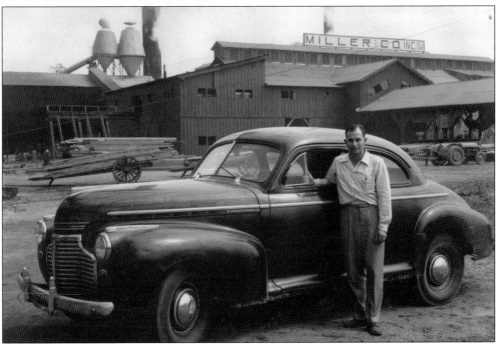

Elmer Sidney Miller founded Miller Lumber Company, Inc. in 1923, and it continues to operate in the same location at 500 Hooper Drive. Alabama was considered one of the fastest-growing timber-producing states, particularly of hardwood trees. With an eye on conservation and preservation of the forests, Miller practiced select cutting and replanting. During World War II, the company had contracts with the government to supply wood for shipbuilding, tent stakes, and other various needs. Later, lumber was sold to Plymouth for station wagon bodies, RCA for TV cabinets, Zildgen for drumsticks, and for furniture manufacturers in North Carolina. (BRC.)

Edgar Cayce (1877–1945) has been called the "sleeping prophet" and "father of holistic medicine" and was the most documented psychic of the 20th century. For more than 40 years, Cayce gave psychic readings to thousands of seekers while in an unconscious state, diagnosing illnesses and revealing lives lived in the past and prophecies yet to come. An accomplished photographer, Cayce and wife, Gertrude, pictured at right, operated a successful photography studio at 21 Broad Street from 1913 to 1923. At a young age, Cayce vowed to read the Bible for every year of his life, and at the time of his death in 1945 he had accomplished this task. Devoted churchgoers, the Cayce's attended First Christian, where he was a much sought-after Sunday school teacher. Cayce is pictured below (sitting, center) with his Sunday school class. When asked how to become psychic, Cayce's advice was to become more spiritual. (Selma–Dallas County Public Library.)

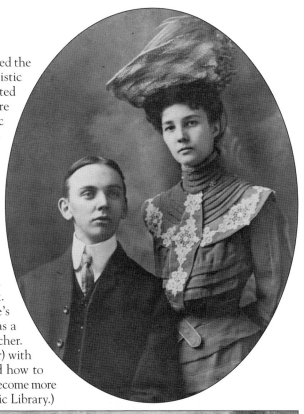

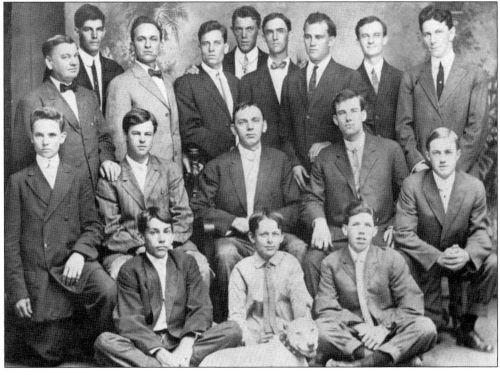

Downtown Selma was the place to go for window-shopping and even an occasional street performer. Selma's youth were drawn to downtown for their entertainment, shopping, and food. (BRC.)

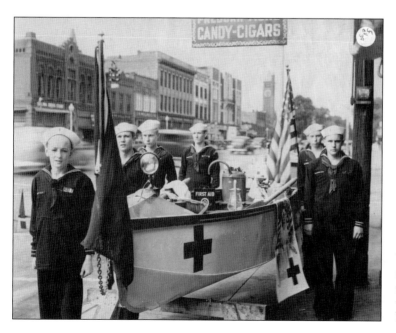

Young men show their support for the war by assisting with a Red Cross blood drive. (BRC.)

The Hohenberg Cotton Company evolved from a country store into one of the largest cotton enterprises in the world. Immigrant brothers Morris and Adolphe first came to Selma in 1876 and established M. Hohenberg & Co. in 1879. Morris settled in Selma and Adolphe in Wetumpka. Together, they were principals in the First National Bank of Wetumpka; operated a lucrative cotton enterprise, a mercantile company, large grocery and dry goods stores; and held extensive interests in real estate, farming, and timber in Elmore County. As the next generations of Hohenbergs came of age, they opened offices in cotton towns throughout Alabama, the South, and later all parts of the world. By 1975, the Hohenberg Brothers Cotton Company was one of the largest and most successful in the United Sates and the world, buying and selling over a million bales a year. The Cargill Company acquired Hohenberg in 1975, and descendant Julien Hohenberg continued to managed the new entity until 1985. Today, Alabama ranks ninth in highest yields of cotton per state. At right are, from left to right, J.A. "Jim" Minter III, J.A. "Jimmy" Minter Jr., and Charles Hohenberg in the 1950s. (Minter family.)

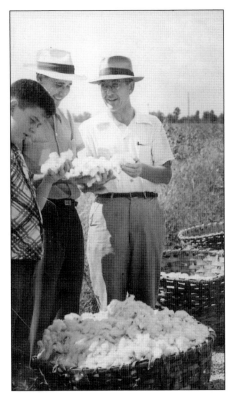

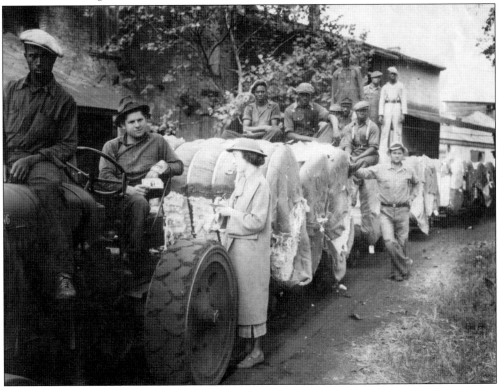

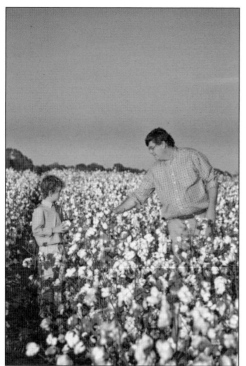

In the early 1800s, Anthony Minter settled with his wife in Tyler, just outside Selma. His son John Morgan was drawn to farming at an early age and began his business career as a merchant and a planter. Over the years, the Minter family business interests and land holdings continued to grow and prosper. Their family home was a fine example of Southern architecture. In 1930, the family incorporated their businesses under J.A. Minter & Sons and continued to operate their general merchandise store, pictured below in the 1950s, which supported their extensive farming enterprises and provided goods and services for 200 area families. The Minter Gin Company, dating back to the 1890s, was in continuous operation until 2002. Collectively, the Minters have farmed the same land for six generations. Pictured at left in 2012 in the midst of a bumper cotton crop are James A. "Jay" Minter IV and his son James A. "Cink" Minter V. Jay is the sixth generation of Minters to grow cotton and the current operator of J.A. Minter & Sons. (Minter family.)

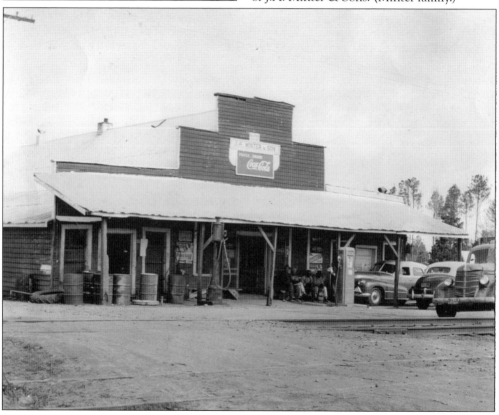

Selma's economy improved as the United States prepared to enter World War II, and the US Army Air Force established a training base here in 1941. This installation was named Craig Field in honor of Selma native Bruce Kilpatrick Craig, a test engineer who had recently lost his life in the crash of a B-24 bomber near San Diego, California. Before the end of World War II, more than 9,000 pilots had earned their wings at Selma's airbase. Craig Field continued to be a major source of jobs and income for Selma residents until its closure in 1977. (Craig Field Airport and Industrial Complex Authority Archives.)

Craig was the home of the Jet Qualification Course, Basic Instructors, and Supervisors School. Military and civilian pilots, from America, Saudi Arabia, Norway, Chile, Iran and others nations trained at the base. (Craig Field Airport and Industrial Complex Authority Archives.)

The City of Selma fought vigorously to keep Craig Air Force Base open after it was selected for closure in 1976. A contingent of Selma's elected officials and business leaders, including Roger Jones, Mayor Joe Smitherman, Otha Carneal, Carl Morgan, and Sewell Jones, travelled to Randolph Air Force Base to lobby against the closure. In a letter addressed to the president of the United States, dated January 20, 1977, Sen. James Allen stated, "Closing of the base would have a near-catastrophic economic effect on Selma and Dallas County." Unfortunately, the lobbying efforts were unsuccessful, and Craig Air Force Base closed on September 30, 1977, severely impacting the economies of Selma and Dallas County. (Craig Field Airport and Industrial Complex Archives.)

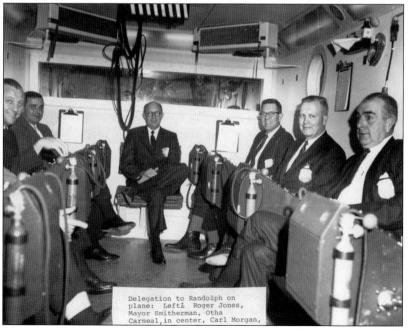

Delegation to Randolph on plane: Left: Roger Jones, Mayor Smitherman, Otha Carneal, in center, Carl Morgan,

Five

HISTORIC HOMES AND ARCHITECTURE

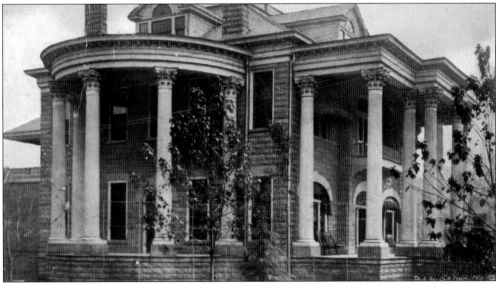

Selma is the second-oldest surviving city in the state of Alabama. Its Old Town Historic District, in the National Register of Historic Places, encompasses 323 acres and is the largest historic district in the state. Brownstone Manor, on 330 Lapsley Street, was built in 1904 for Selma businessman J.B. Ellis. The home was visited frequently by F. Scott and Zelda Fitzgerald when it was owned by Lamar Hooper. Today, it remains a private home but also hosts special events and weddings. (Selma–Dallas County Public Library Archives.)

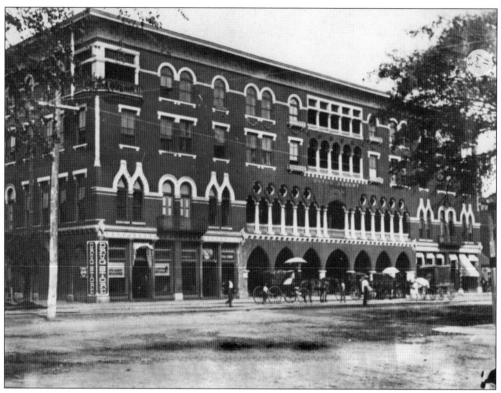

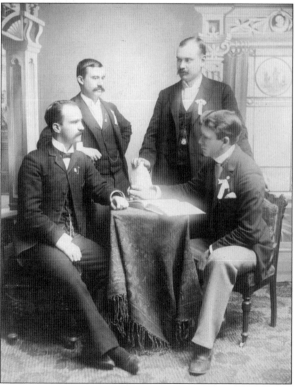

The Hotel Albert encompassed a full city block along Broad Street between Dallas and Selma Avenues. The hotel was chartered as the Broad Street Hotel Company on February 15, 1854, but the investors could not raise the $100,000 necessary for construction until 1860. The wood, brick, and stone structure was built in a Venetian style, inspired by the Doges Palace. It had a frontage of 175 feet with a large and beautiful courtyard in the rear. Work was suspended in December 1861 due to the Civil War. Union troops used the partially completed building as a headquarters following the Battle of Selma in 1865. Pictured at left are Selma resident William Washington Quarles (seated, left), who served as the national president of Phi Delta Theta fraternity, with fellow Phi Delta officers at the Albert Hotel. (BRC and Shirley Quarles Baird.)

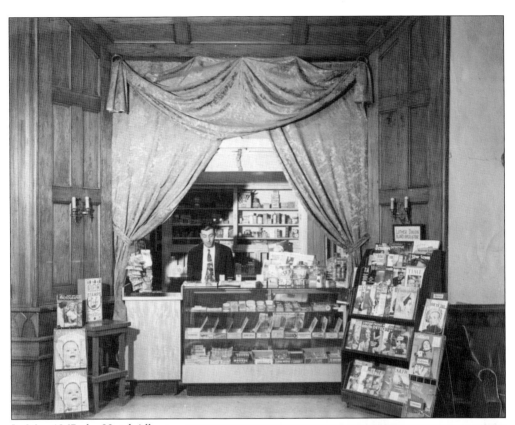

In May 1867, the Hotel Albert property was acquired by the National Hotel Company of Selma, and work resumed on the building. A roof was built, and the first two floors were finished and opened to guests. It took several additional years for the third- and fourth-floor interiors to be made habitable. The hotel was sold in 1891 to a group of stockholders, organized as the Hotel Albert Company in honor of Albert G. Parrish, who was vital in securing the funds for the purchase. The full Hotel Albert opened to the public in February 1893, and the building was pronounced "one the handsomest pieces of hotel architecture in the South." At right, Selma's ladies, dressed for lunch, meet in front of the hotel's columns. (BRC.)

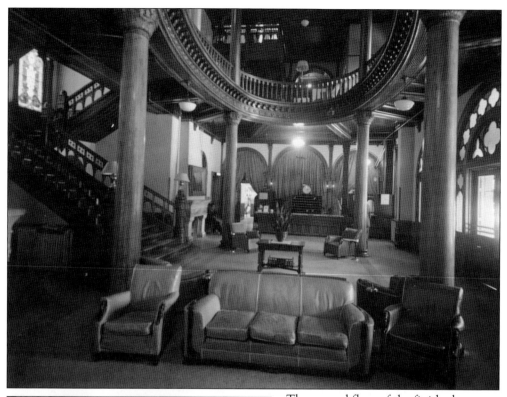

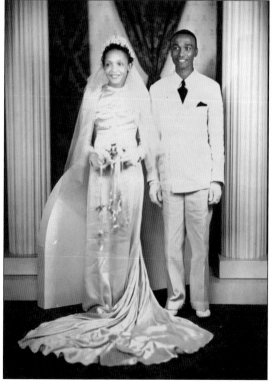

The ground floor of the finished hotel had a grand lobby, including an elaborate oak staircase from the 1860s; it also housed the hotel offices, eight stores, a barber shop, billiard room, bar, laundry, and elevator entrance. The second floor had a 41-foot-by-71-foot dining room with a bronze ceiling, oak paneling, and stained-glass windows. It also featured a large pantry, kitchen, children's dining room, multiple reception parlors, a bridal suite, and 11 guest rooms. The third floor had 38 guest rooms, and the fourth had 43 rooms. The hotel hosted many weddings during it heyday; pictured at left are newlyweds Mr. and Mrs. Richard Moore. Balconies on the two upper floors were eventually enclosed, and the observation tower on the roof was removed. The hotel was reconditioned and modernized in 1953–1954. The hotel was demolished in 1969 to make way for the current city hall and the Selma–Dallas County Public Library complex. (BRC and Shirley Quarles Baird.)

The antebellum home below was built by Col. Washington McMurray Smith in 1859. During the Battle of Selma, the first floor was used as a hospital for Union troops, while the Smith women and children were allowed to reside upstairs. Colonel Smith, seen at right, was the president of the Selma Bank, and as Union troops descended on Selma, he, with the aid of slaves, removed the gold from the bank vaults and deposited it in the south column of his home. A hole was cut in the column near the second-story balcony, and the gold dropped to the bottom. According to descendant Shirley Quarles Baird, "Even though the Yankees used the home as a headquarters and searched diligently for the missing gold, they walked by it every day, but they never found it." Colonel Smith returned the gold to the bank after the Union troops departed. The Smith-Quarles home is one of the few antebellum homes in Selma still owned and occupied by a descendant. (Shirley Quarles Baird.)

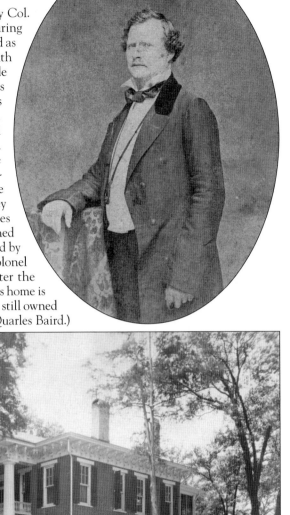

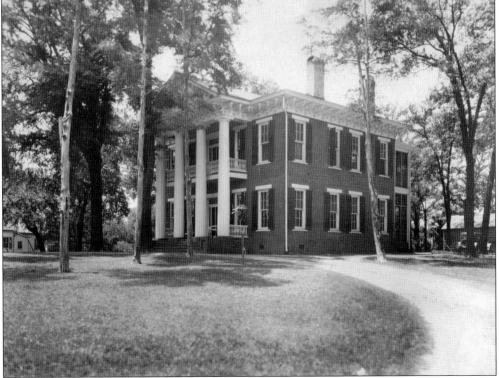

The long line of Smith-Quarles descendants who have called 439 Lapsley Street home include George Park Quarles and Shirley Carolyn Berry, pictured at left during their honeymoon in 1939. Their daughter Shirley Quarles Baird was born and raised in the home and is the current occupant. Shirley is seen below in her finest Easter bonnet. A total of five generations of the Smith-Quarles family have occupied the home. (Shirley Quarles Baird.)

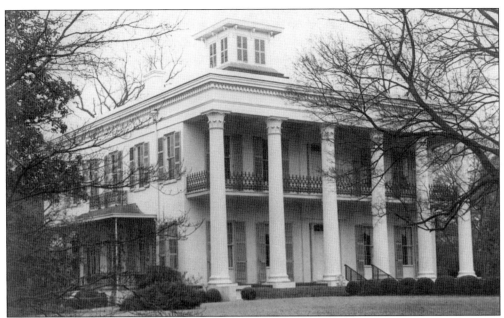

Sturdivant Hall, located at 713 Mabry Street, has been deemed the "finest Greek Revival, Neo-classic antebellum mansion in the Southeast." Built in 1852–1853 as a townhouse for Col. Edward Watts, the 10-room, 6,000-square-foot mansion cost $69,900 to construct. Artisans from Italy were brought in to do the exquisite plaster and marble work throughout the home; the marble was imported from Carrera, Italy. The home was sold in 1863 to John Parkman, a young bank president, for $65,000. Parkman was arrested for bank fraud and drowned in the Cahaba River while trying to escape. His widow sold the home to Emile Gillman for $12,500. The Gillman family descendants owned the home for the next 87 years (1870–1957). The City of Selma purchased the home in 1957 for $75,000, and the estate of Robert Daniel Sturdivant contributed $50,000 and furnishings toward the development of a museum and named it Sturdivant Hall. The magnificent four-poster bed below, from around 1850, is made of mixed woods. The hand-knit bedspread, from around 1872, was spun on a spinning wheel and knitted on small, steel needles. Disguised as a stool, the room's chamber pot was a necessary item in the bedroom. (LOCDC.)

Inside Sturdivant Hall, there is grandeur in its scale and magnificence in its presentation. The exterior brick walls start at the ground, and the interior walls and columns are covered in stucco and scored to resemble stone. The intricate ceiling work was done with molds and a form of plaster of paris. Twin parlors located on the first floor were used primarily for entertaining. A beautiful gold leaf mirror over the mantel and the matching Victorian parlor furniture were gifts to Sturdivant from the estate of Mrs. Annie King, a beloved Selmian. The Maring Room housed the library and music room and included exquisitely ornate molding carved with grapes and leaves. The four staircases in the home are cantilevered (suspended from the wall). Exceptional light fixtures, made in Philadelphia by the Cornelius and Baker Company, are solid brass and are original to the home. Out of necessity, the home's kitchen and smokehouse were separate structures located at the rear of the home. (LOCDC.)

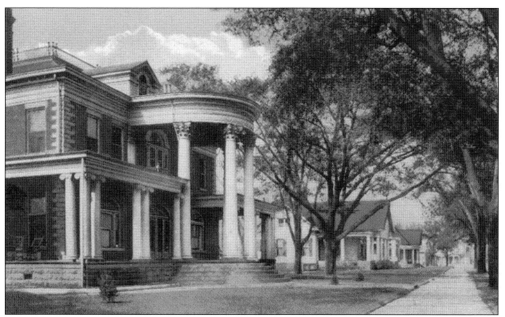

Julien Smith, a native of Dallas County, lived his adult life in Selma. A talented civil engineer, he was elected city engineer, operated a fire insurance business, and owned 6,000 acres, divided into several plantations, in Dallas County. In 1903, he built his beautiful, 7,000-square-foot Victorian home at 627 Church Street. Known as Ashford, the home featured a double parlor with parquet floors and beautiful fireplaces. (Selma–Dallas County Public Library.)

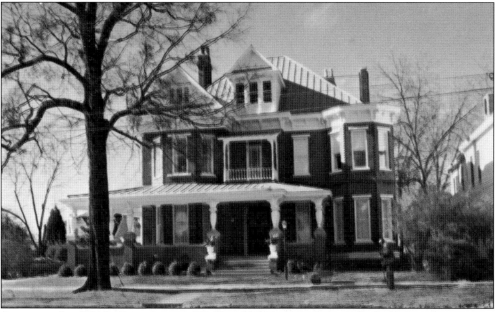

Constructed in 1893 by Ernest Lamar, 327 Church Street hosts a two-and-a-half-story, 6,700-square-foot, 10-room Queen Anne home with neoclassical influences. The wraparound porch is supported by urn-shaped columns with Ionic capitals. A turret originally located above the second floor was removed and converted into a playhouse. Today, the beautifully manicured home is occupied by the Henry family and is known as Churchview. (Selma–Dallas County Public Library.)

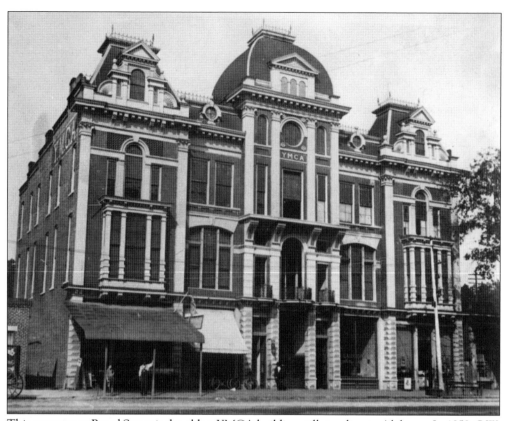

This structure at Broad Street is the oldest YMCA building still standing in Alabama. In 1858, C.W. Buck and others met in Selma and formed a Young Men's Christian Association. Its purpose was to serve young men in need of boarding and recreation. In 1875, the YMCA library was founded, and by 1876 the library had 600 volumes. Though the building has been vacant for many years, many of the architectural features that existed in 1887 can still be seen today. In 2013, the Selma–Dallas County Historic Preservation Society completed a stabilization project for the YMCA. The Selma YMCA proudly led the way in diversity with an organized program for African Americans in 1945 and the creation of the George Washington Carver Branch YMCA in 1952. The Carver YMCA, located at 802 First Avenue, would later be renamed Claude C. Brown in recognition of the community activist and pastor of Knox Reformed Presbyterian Church. (BRC.)

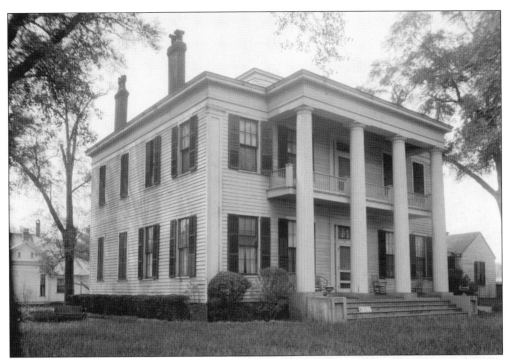

The King-Siddons-Welch House, at 697 Union Street, was constructed in 1853 for William B. King, nephew of Vice Pres. William R. King. It was named Fairoaks for the many trees found around the property. The home was sold to Judge Franklin Siddons in 1862. Following the Battle of Selma, the property was occupied by Wilson's Raiders and used as a hospital for Union soldiers. Mrs. Siddons and her two small children were allowed to occupy two of the upstairs rooms and given "kitchen privileges," but she had to enter the kitchen by the backstairs. In 1887, the home was purchased by the Welch family, who occupied it for nearly 100 years. In 1981, the Greek Revival mansion was purchased by Larry Striplin Jr. and refurbished for his corporate headquarters. Striplin renamed the home Henderson House in honor of his mother, Ethel Henderson. Striplin, an only child, is pictured at right with his mother in 1933 at their home at 108 Lamar Street. (LOCDC and Larry Striplin Jr.)

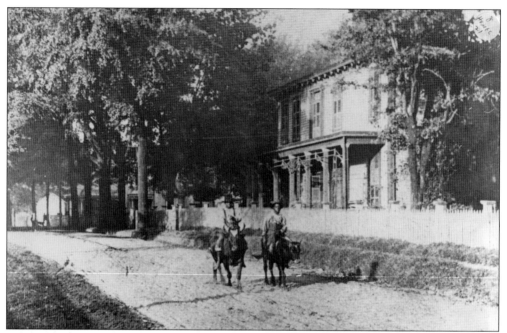

The home of Dr. John Furniss, located on Furniss Avenue between Broad and Lauderdale Streets, was dismantled in 1954. During the Civil War, Dr. Furniss was an assistant surgeon in the Confederate Army. The two young men in the photograph have selected rather unusual modes of transportations.

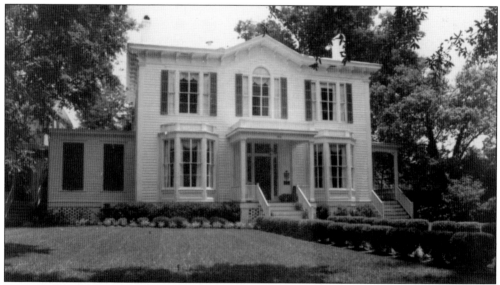

Grace Hall, at 506 Lauderdale Street, was built in 1857 by Henry H. Ware. The architecture mixes elements of the older neoclassicism with the newer Victorian trends that dominated Alabama architecture after 1850. Prominent owners included Madison Williams, Selma mayor from 1865 to 1866, and the Stollenwerck, Baker, and Jones families. In 1865, Wilson's Raiders spared the house out of respect to Selma mayor Williams. Restoration of the home was undertaken in 1981–1983 by the C.E. Dillon family, and the home was named Grace Hall in honor of Grace Jones, a longtime occupant and owner. (BRC.)

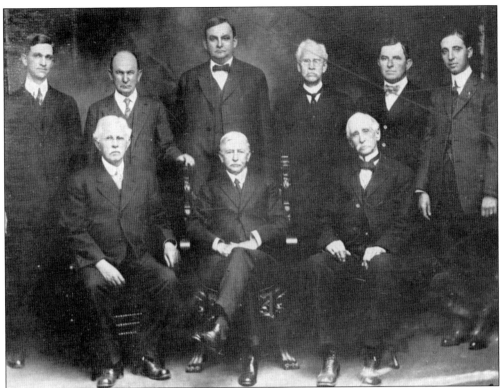

Albert Garrett Parrish (above, back row, fourth from the left), born in 1850, entered business in Selma on February 3, 1869, with the Selma Fire and Marine Insurance Company. The company later merged with the City Bank of Selma, becoming the City National Bank on November 12, 1870. Starting as a messenger boy for the bank, Parrish advanced to the presidency in 1901 and remained there for almost 60 years. Parrish was director and president of the Hotel Albert Company and served on the Selma School Board for 33 years. In 1939, in recognition of his commitment to the children of Selma, the new high school was named in his honor. The Parrish residence was built in 1938 at Selma and Union Avenues. (Selma–Dallas County Public Library.)

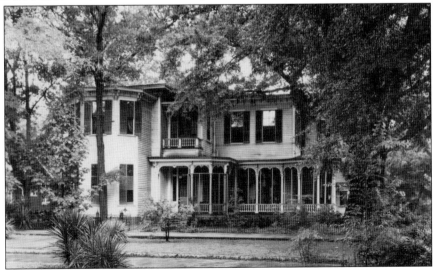

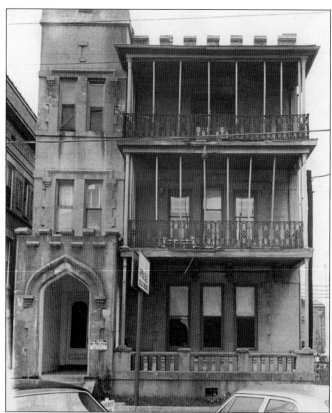

The Castle Garden Apartments was one of Selma's most unique buildings. It was located on Alabama Avenue next to the old courthouse. The building was demolished in late 1968. (Old Depot Museum.)

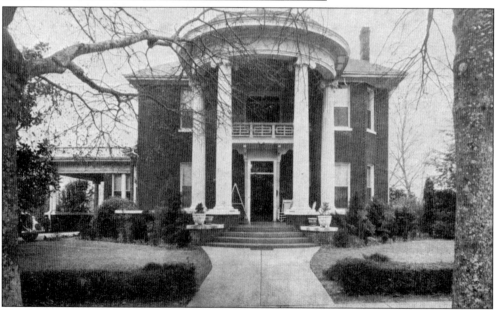

The Silent Night Guest Home, at 2201 Broad Street, was operated by Mrs. L.G. Pierson. According to its ads, it "offered modern accommodations for discriminating travelers; all rooms with baths; ample parking in a beautiful residential section." Today, the home is a private residence. (Selma–Dallas County Public Library.)

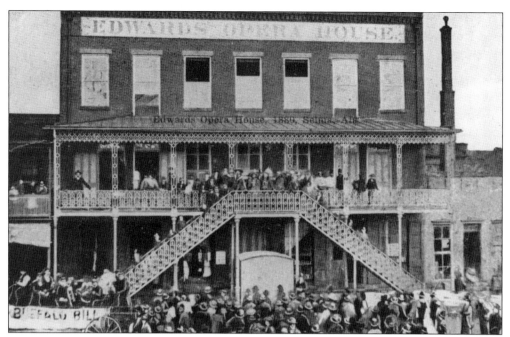

The Edwards Opera House and the Academy of Music were operated by Louis Gerstman, a Selma insurance agent, from 1879 to 1896. On the stairs is the cast from Buffalo Bill's Wild West show; pictured in the center are performers Chief Sitting Bull and Annie Oakley. A fire destroyed the opera house on January 10, 1884. (BRC.)

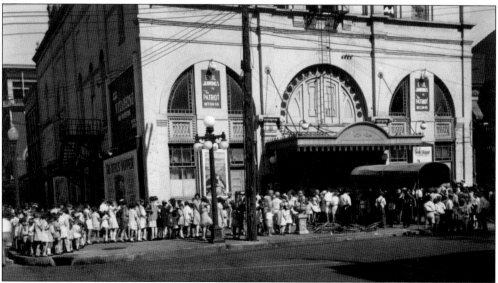

The Academy of Music opened on November 10, 1885, featuring the Milan Italian Opera Co. The *Selma Times Journal* reported, "It was an unforgettable and gala occasion for the people of Selma when the theatre first opened its doors. For miles around they came . . . to witness the first great stage performance of that day which marked the beginning of a long period in the history of the theatre." Performers included Lillian Russell, the Ziegfield Follies, and Will Rogers. A large organ provided sound for silent movies. In 1938, with the advent of talking motion pictures, the old academy was transformed into the Wilby Theatre. (BRC.)

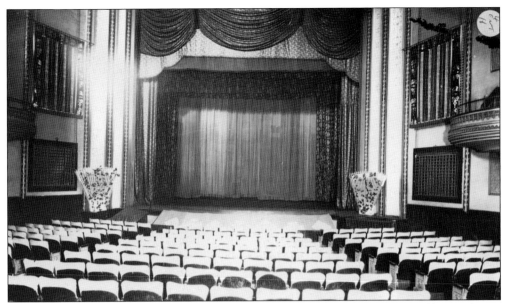

The Wilby Theatre retained the grandeur and the realistic tone qualities of the old opera house and was known as "Alabama's finest sound theatre." The theater was destroyed by a fire and closed in the early 1970s. When the building was demolished, some of the furnishings were rescued and are on display at the Vaughan-Smitherman Museum. At one time, Selma claimed four theaters: the Wilby, the Walton, the Roxy, and the Selmont drive-in. Young people would line up around the block for the Saturday movies and variety shows. Selma's famed civil rights activist Dr. F.D. Reese's first job as a young man was cleaning the Wilby Theatre. His predecessor had been fired for not doing a good job, but Reese was confident that he could pass his boss's white glove test. Reese would go onto graduate from college, serve as a principal, was the leader of the Selma public school teachers' organization, became president of the Dallas County Voters League, and was a key figure in the voting rights movement. (BRC and Selma–Dallas County Public Library.)

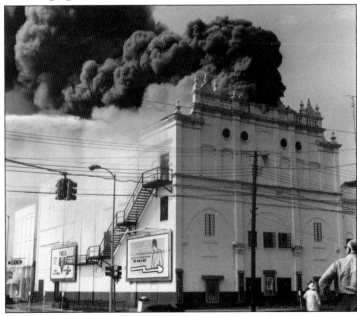

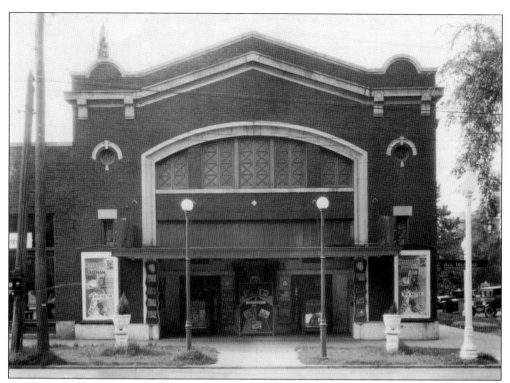

The Walton Theater opened in 1914. The theater was considered a "B" movie house; however, in 1932, it garnered national attention when it was converted into an "all-talking" picture show. The renovation included the installation of a new Western Electric sound system, redesigned foyer, and new decor, making it, according to *Selma Times-Journal*, one of "the most attractive in this section of the country." During the late 1940s, a typical weekend night at the Walton included a feature movie, local talent acts, newsreels, and a short comedy. By the 1970s, the Walton Theater was closed and on the verge of crumbling. In the early 1980s, Selmians took up the cause of the Walton and launched a project to restore and enlarge the facility. Philanthropist Larry Striplin, singer Anita Bryant, and the community raised over $1 million, and in May 1985 the Larry D. Striplin Performing Arts Center opened for business. The center was designed to house theater productions and movies. The first event held in the new center was the children's movie *Blackbeard's Ghost*. Below, a group of Walton Theater ushers poses for the camera. (BRC.)

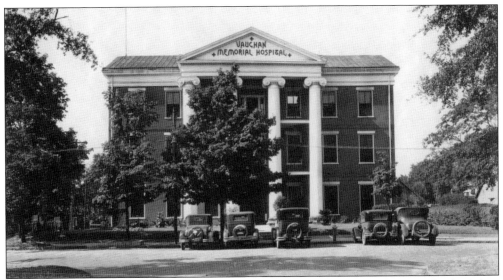

What is now known as the Smitherman Historic Building was constructed in 1848 by the Selma Fraternal Lodge No. 27 of the Free and Accepted Masons as a school for orphans and children of indigent Masons at a cost of $15,000. The school, which operated for only a few years, was the first of many uses for the building. During the Civil War, the building was a Confederate hospital and as the Freedman's Bureau Hospital (1865–1868), dedicated to treating former slaves mostly stricken with smallpox. It was then purchased by the City of Selma and offered to Dallas County as a courthouse to attract the county seat to Selma from Cahawba, and it remained in that capacity until 1902. Vacant until 1904, the building was used by the Selma Military Institute until 1908. Purchased by the trustees of the Henry W. Vaughn estate, the versatile building was converted into a hospital and operated as the Vaughn Memorial Hospital (1911–1960), when a new hospital building was completed on West Dallas Avenue. In 1969, the City of Selma once again purchased the building, for $82,5000, and under the leadership of Mayor Joe T. Smitherman it was restored for community use. (BRC and Selma–Dallas County Public Library.)

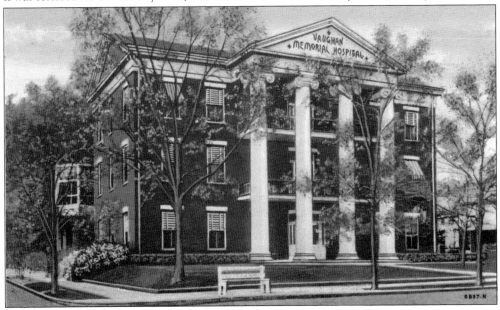

Six

QUALITY OF LIFE

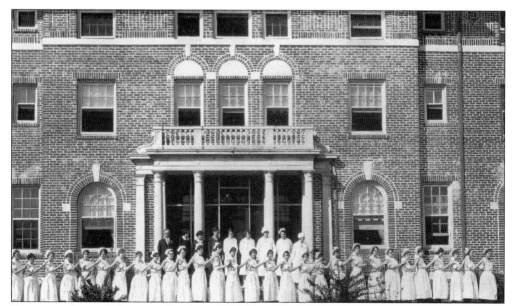

From its infancy, Selma was the center of religious worship, education, and medicine in west Alabama. In 1890, Selma incorporated its first public board of education, and between 1890 and 1922 seven hospitals were opened: Selma Infirmary, the King Sanitarium, Union Street Hospital, DuBose Sanitarium, Burwell Infirmary, Alabama Baptist, and Good Samaritan Hospital. Pictured here is the Selma Baptist Hospital nursing class (1927–1929). (Old Depot Museum.)

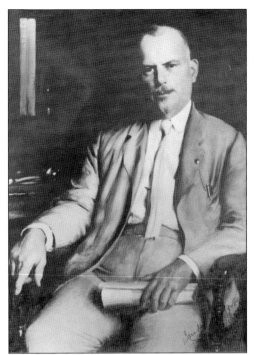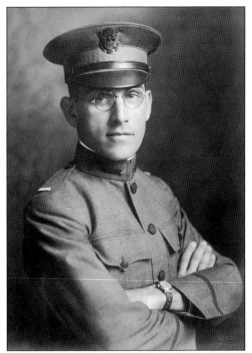

The will of the late Henry White Vaughan provided funds for the erection of a private hospital for the white people of Selma, in memory of his father, Dr. Samuel Watkins Vaughan. The trustees of his estate purchased the old courthouse, renamed it Vaughn Memorial Hospital, and contracted the DuBose Sanatorium staff to operate the hospital. The staff included Dr. Francis G. Dubose (1873–1941), at left, and Dr. Clarence Couch Elbash (1888–1927), at right, and other trustees, including H.D. Mallory, W.M. Vaughan, J.F. Hooper, Dr. J. Chisolm, Dr. S. Kirkpatrick, and Dr. B.B. Rogan. The three-story brick building was reconstructed and operated as a first-class private institution for 20 years. There were 40 rooms in the main building, 30 private beds, and an elevator, dumbwaiter, and electric call bell system. The floors were made of Marbelite, and the building was heated by a hot water system. For safety reasons, the boilers and furnaces were located 15 feet away from the main building in a concrete and brick cellar, removing all possibility of a fire from this source. The kitchen was made of cement and was vented above the main building to insure freedom from cooking odors and smoke. There was over 3,000 feet of porch space, including an open-air solarium. (City of Selma and Smitherman Vaughn Museum.)

Dr. Goldsby King (1860–1920), the grandson of Thornton B. Goldsby, founded Selma's first private hospital in 1896 on Mabry Street. Upon graduation from medical school, he returned to Selma and was appointed the city physician. Goldsby King Hospital was recognized throughout the South as one of the finest private hospitals. When questioned about the hospital's luxuries, Goldsby was quoted, "Some men have their yachts. My hospital is my yacht and I prefer to spend my money that way." The hospital's herd of Jersey cows supplied patients and staff with milk and butter, and Mrs. Annie Graham King personally prepared most of the breads, jellies, and desserts. Meals were served on silver trays, complete with flowers, Haviland china, and white linen. The latest instruments were found in the operating rooms, and all nurses were graduates and carefully selected. Passionate about his religion and foreign missions, upon his death at age 59, Annie sold the hospital and gave the proceeds, his instruments, and library to start the Goldsby King Memorial Hospital in China. (Selma–Dallas County Public Library.)

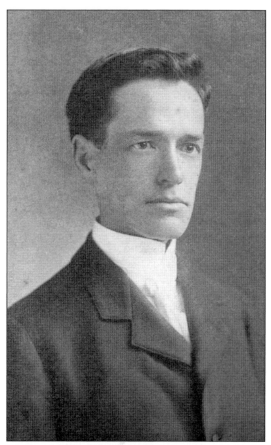

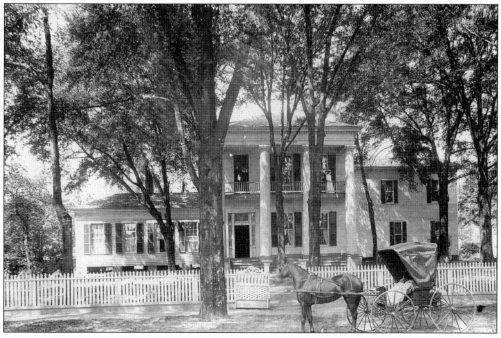

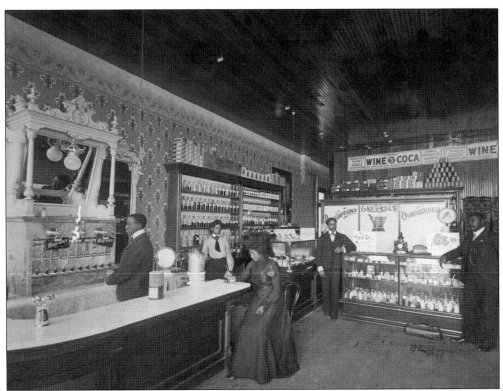

Dr. Lincoln Laconia Burwell was a prominent physician and businessman. He graduated from Leonard Medical College of Shaw University in 1890 and practiced medicine in Selma for 40 years. During that time, he founded the Burwell Infirmary, on Philpot Street, one of Alabama's first hospitals for African Americans, and the Burwell Drug Store at 1014 Franklin Street. The infirmary had one operating room, and its rooms were equipped with modern hospital beds and furnishings. Dr. Burwell held leadership positions in the National Baptist Association and the National Medical Association. (BRC and New York Public Library Archives.)

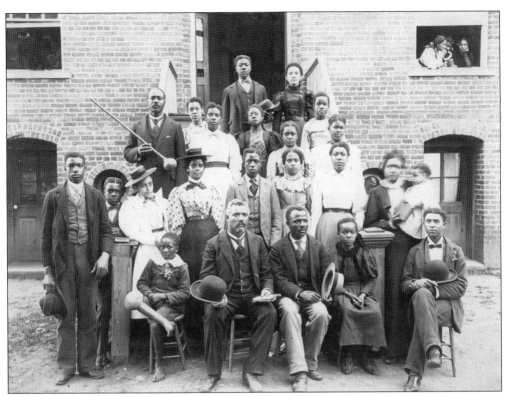

Rev. Charles Spencer Dinkins, pictured above (in front with the bowler hat), served as president of Selma University from 1893 to 1901 and was a strong advocate of education for African Americans. Well educated himself, he graduated from Roger Williams University (1877) and Newton Theological Seminary (1881). Dinkins Hall, erected in 1904, is named in his honor. His son William was a 1912 graduate of Brown University and received a master's degree from Columbia University. William served at Selma University from 1927 to 1950. Rev. Dinkins daughter Pauline, at right, graduated from Women's Medical College (Drexel University) in 1919 and was one of the first Alabama women to become a physician. She was the house physician at Tuskegee Institute Hospital and medical director at Brower Hospital in Greenwood, South Carolina. Pauline received advance study in London, and ran a hospital in Monrovia, Liberia, before returning to Selma to set up a medical practice. (Black Belt African American Genealogical and Historical Society.)

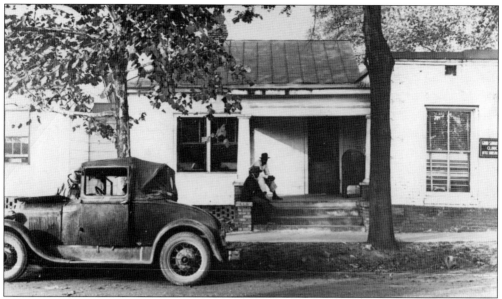

In 1922, the Baptists founded Good Samaritan Hospital in the building that had previously belonged to a prominent African American family, the Sullivans, and entrusted its care to Tuskegee graduate Mayme Clark Norris (1888–1951), a registered nurse. Pictured below are the 11 children of William F. Clark, the son of Dr. Courtney Clark. They are, from left to right, (first row) Sidney, Ann, Gussie, Frank, Maerjean, and Osceola; (second row) Bessie, Mayme, Helen, Edwin, Grace, Ruby, and Mattie. Mayme ran "Good Sam" until it was converted to a Catholic hospital under the care of the Edmundite Missions in 1944. The organization was started in 1937 by the Society of Saint Edmund in response to an appeal from Pope Pius XI to undertake a special ministry to African Americans in the Deep South. Over the years, the Edmundites was joined by sisters from several religious orders, who ministered with the fathers and brothers of the society and provided direct assistance to the needy. Fr. Frank Casey was the founder and first director of the Edmundite Southern Missions, helping to build churches, hospitals, and schools in Selma. (BRC and Clark/Williams family.)

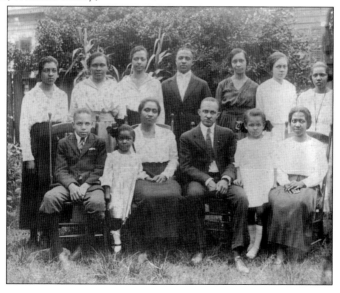

Soon after the Edmundite Missions took over Good Samaritan Clinic, it built a new, modern hospital at 1107 Voeglin Avenue. The state-of-the-art hospital remained operational until 1983, providing superior care to the poor and underserved residents of the Black Belt. Dr. William Dinkins, son of Rev. L.L. Anderson and Pauline A. Dinkins, was the attending physician at Good Sam the night that Jimmie Lee Jackson was shot. Good Sam was the only hospital in Selma to open its doors and treat the scores of wounded marchers who poured into the emergency room on Bloody Sunday and provided the initial treatment for Rev. James Reeb. (Selma–Dallas County Public Library and the Edmundite collection.)

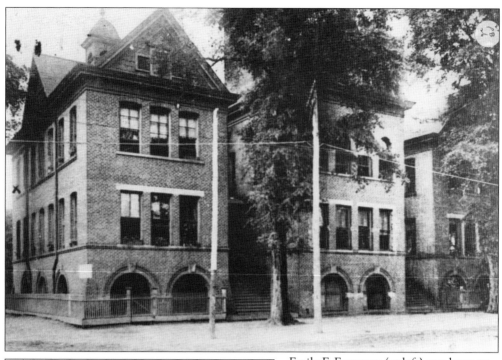

Emily F. Ferguson (at left) was born on November 15, 1838, the daughter of Hugh Ferguson and Caroline Minter. She was educated at Dallas Academy (above) and graduated in a class of three in 1858. During the Civil War, she worked in the Selma arsenal making cartridges. In 1868, when the city inaugurated its public school system, she began her teaching career. Upon the death of Superintendent Hardeway, she became the first female superintendent in America. A strong supporter of the Confederacy, she organized the Selma chapter of the United Daughters of the Confederacy and was a charter member of the Cherokee chapter of the Daughters of the American Revolution. (BRC and the Old Depot Museum.)

In 1838, the Ladies Educational Society, consisting of Elizabeth Treadwell, Ann Weaver, Mrs. William Wadell, Maria Parkman, Margaret Morgan, Caroline Ferguson, Mrs. Robert L. Downman, Mrs. Robert Patteson, Mary Conoley, Mrs. Andrew Hunter, Sarah Maples, and Mrs. Uriah Griggs, was organized. The women were a formidable force, and they pushed their husbands into action to address the lack of an organized educational system. In the years that followed, they helped build the original Masonic Academy (now the Smitherman Vaughn Museum) and the Dallas Academy. The school's immediate success prompted the women to reorganize and a new board, now under the control of husbands, Philip J. Weaver, Thomas J. Frow, Wesley N. Plattenberg, John W. Jones, Peyton S. Graves, David A. Boyd, Edward W. Marks, William Seawell, George W. Gayle, Drewry Fair, and John Mitchell, was formed. The Ladies Educational Society continued to operate as a volunteer group, assisting in fundraising. The Dallas Academy would become Selma's first public school and the foundation for the Selma public school system, the second oldest in Alabama. Pictured below is an early class from Dallas Academy, and above is the 1916 graduating class of Selma High. (BRC and the Old Depot Museum.)

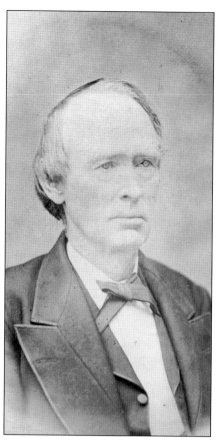

Dr. Courtney James Clark, at left, was born in 1816 in South Carolina and began practicing medicine at age 20 in Benton, Alabama. Dr. Clark served as the first assistant surgeon of the Alabama Volunteers in the Mexican–American War. In 1861, he joined the Confederate Army and was appointed chief surgeon of the 10th Alabama Regiment. His first assignment was on the bloody field of the First Manassas. Recognized as a great surgeon, he was placed in charge of the Alabama hospitals until April 1865. By the end of the war, Dr. Clark was performing surgeries on Confederate and Union soldiers. In 1866, Dr. Clark moved to Selma and established a practice at 21 Broad Street. Over the years, he served on the city council and the Selma City School Board (1890) and was the chairman of the board for the Dallas Academy. Dr. Clark arrived in Selma with two families, one white with wife, Nancy, and one black, with Mary, his cook. Reportedly, their combined 11 children were raised in tandem on the same land and maintained a "sense of family relations." Dr. Clark was committed to educating all of Selma's children, and he secured an amendment to the city charter that set apart city revenues for the public schools. When Burrell Academy was converted to a public school, it was renamed Clark Elementary. Pictured below are students at Clark Elementary. (ADAH and Clark/Phillips family.)

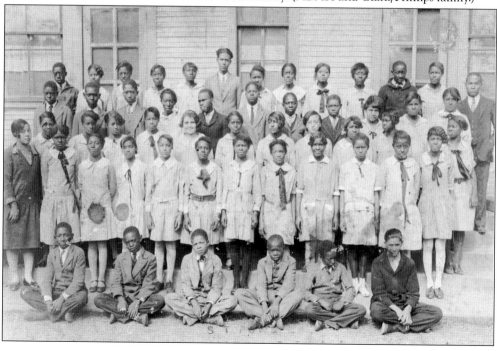

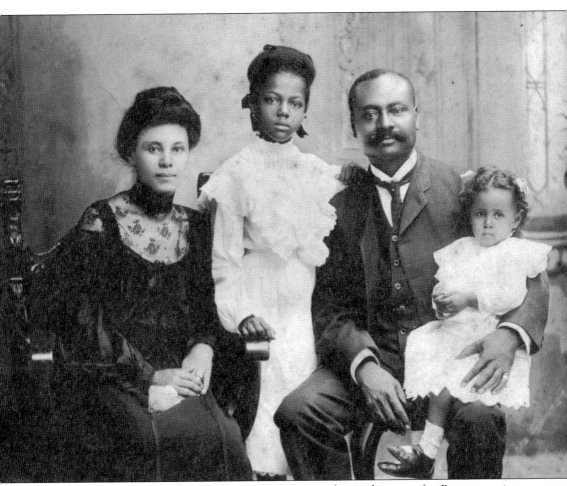

Selma was a major education center for African Americans during the years after Reconstruction. Knox Academy was established in 1874, Selma University in 1878, and Payne Institute in 1889. The Alabama State Teachers Association was founded in Selma in 1882, and two of its first five presidents, George M. Elliot and Richard Byron Hudson, were from Selma. Richard "R.B." Hudson (1866–1931) was a graduate of Selma University, an experienced educator, a leader in the National Baptist Convention, and an astute businessman. He served as principal of Clark Elementary School for 40 years, and in 1949, when the new African American high school was built, it was named R.B. Hudson High in his honor. As a businessman, Hudson was instrumental in bringing the Penny Savings Bank to Selma, and he owned one of the largest coal and wood yards in the state of Alabama. His coal yard covered a half block on the corner of Vogelin and Green Streets. Booker T. Washington of Tuskegee University offered high praise of Hudson: "He has shown himself on each occasion to be a leader of rare ability." Pictured are Hudson, his wife Irene, and their two daughters in their stately home at 1420 Lapsley Street. (Black Belt African American Genealogical and Historical Society.)

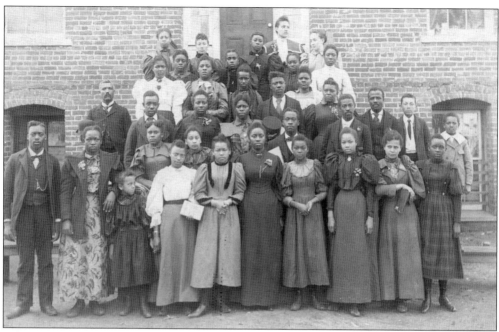

Selma University was considered one of the most important schools in Selma. In 1874, the Alabama Colored Baptist State Convention approved the development of a separate theological seminary, and in 1877 Selma was selected as the school site. The school, which opened in 1878, trained ministers and teachers and offered pre-college level courses. The industrial work department included sewing, millinery, and domestic sciences. Located on Lapsley Street and First Avenue, the site of the old fairgrounds, the 36-acre campus consisted of three large brick buildings. During its early years, the school was known as the Alabama Normal and Theological School, then Selma University, Alabama Baptist Colored University, and back to Selma University. The school's early presidents included Harrison Woodsmall, Rev. William H. McAlpine, Edward M. Brawley, Charles L. Purce, and Rev. Charles S. Dinkins. President Brawley oversaw the conversion to a collegiate level university specializing in training teachers for black schools and in ministerial studies. Today, Selma University operates primarily as a Bible college. Pictured above are Selma University students. (Black Belt African American Genealogical and Historical Society.)

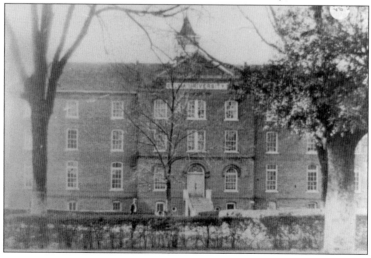

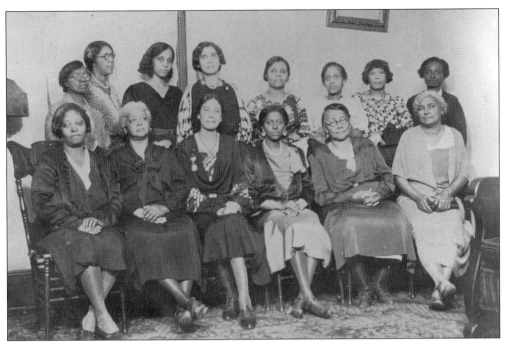

The Progressive Culture Club was organized in 1915 by Lavinia Richardson Burwell, wife of Dr. Lincoln Burwell. It was formed as a civic, service, and social club and is still active today, made up of fourth-generation members. Pictured here are club members in the 1930s. (Old Depot Museum.)

The Six and Seven Literary Club, pictured in 1917, consisted of Selma's leading businessmen and civic leaders. Shown from left to right are (first row) Truman McGill, J.B. Converse, Leo Lava, Rabbi Isador Isaacson, Bob Mangum, and Dr. Eugene Callaway Sr.; (second row) E. Pettus, Dr. W.B. Hall, Lewis Benish, Houston Armstrong, Arthur Harmon, Sam Hobbs, and Lloyd Hooper. (BRC.)

Known as the "mother of black Lutheranism in central Alabama," Rosa Young (1890–1971) was instrumental in founding and promoting the development of Lutheran schools and congregations in Alabama's Black Belt. Born in the rural community of Rosebud in Wilcox County, Rosa had a keen desire to learn and to teach. When she completed her basic education (up to the sixth grade), her parents sent her to Selma's Payne University, where she was valedictorian in 1909. Rosa returned to Wilcox County and opened her own school, starting with 7 students and growing to 215 in just three terms. The school experienced hard times and in desperation to find financial help, Young wrote to Booker T. Washington, and he encouraged her to write to the Board of Colored Missions of the Lutheran Church. The church was supportive of her efforts, and on November 13, 1922, in a rented cottage at 521 First Avenue, the first classes of Alabama Lutheran College were held in Selma. The student body continued to grow, and in September 1925 the first buildings on the present campus were dedicated. On July 1, 1981, the school's name was officially changed to Concordia College. (Old Depot Museum and BRC.)

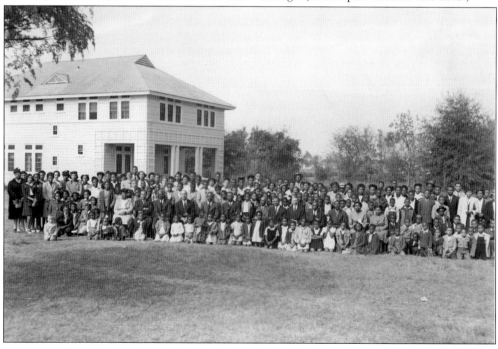

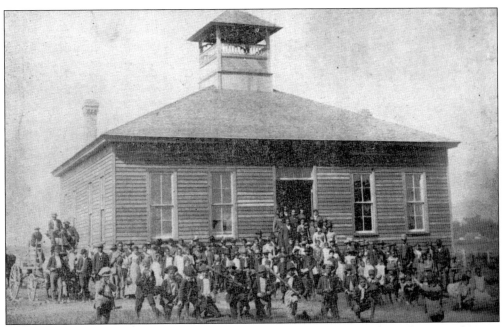

In 1889, the Alabama AME churches created Payne University. It began with 188 students at Brown Chapel and later served over 400 students by the early 20th century. The school stood at 1525 Franklin Street and was named in honor of the noted African American educator Daniel Payne, a native of Charleston, South Carolina. Payne served as official historiographer of the AME church and became the first African American to serve as a college president, shortly after the Civil War at Wilberforce University in Ohio. A 1917 report on AME colleges recognized Payne as one of the largest and most important schools within the denomination. It had 265 students, with 13 teachers, and a campus valued at $35,000. The college remained in Selma until 1922, when a split at the state AME conference led to the college being transferred to Birmingham, where it became Daniel Payne College. Pictured here are Payne School on opening day, November 4, 1889, and an early graduating class. (ADAH and Phillips/Williams family.)

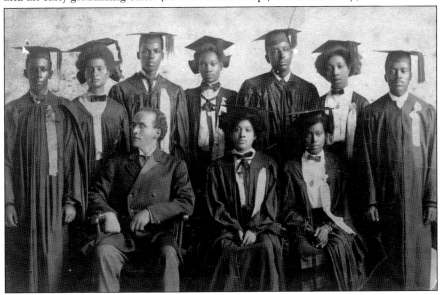

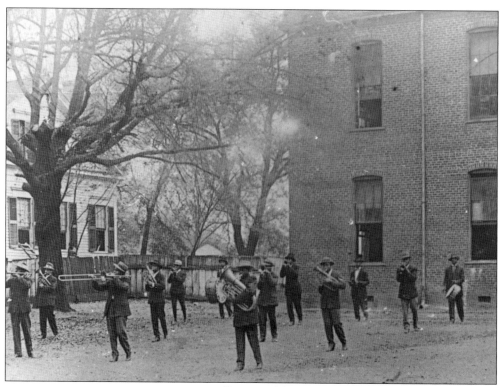

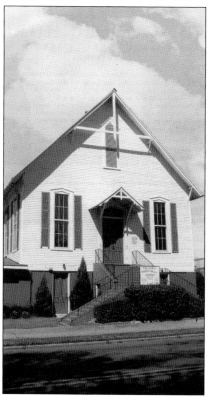

Creating African American churches and schools happened simultaneously with Emancipation and Reconstruction in Selma, as freed men and women worked with various missionary groups and churches. In 1874, Rev. Lewis Johnston, the first African American to be ordained a Reformed Presbyterian minister, arrived in Selma to preach the gospel. On May 21, 1875, the Reformed Presbyterian congregation was organized, and within three years the present church building was erected on North Avenue (now J.L. Chestnut Jr. Boulevard). Because the church was constructed long before the advent of air-conditioning, it was a raised cottage to facilitate the movement of air for ventilation, and the windows originally had closable shutters. The church is listed in the National Register of Historic Places. The Reverend Claude Brown, pastor from 1942 until his death in 1975, worked tirelessly for African American youth and was instrumental in the creation of the African American YMCA. He developed friendships that crossed racial lines and served as the middle ground between Selma's black and white communities during the civil rights and voting rights movements. The Knox Academy Band (above), noted for their lively music and marching style, participated in every Selma parade for nearly a century. (BRC and Madden & Associates.)

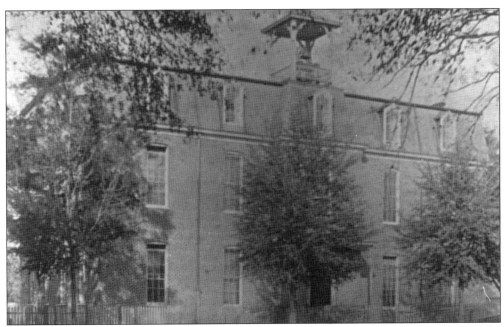

On June 11, 1874, Rev. Lewis Johnson formed Geneva Academy to educate former slaves. The school was later renamed Knox Academy after Scots reformer John Knox. During the Depression, the burden of supporting the school became too much for the church, and the facility was sold to the city, which continued Knox as a public school. The old academy, a large brick, Victorian-style building, was later demolished, and the present Knox Elementary School was built behind the old building site. Pictured below are Knox faculty members. They are, from left to right, (first row) Carrie Scott, Eliza Martin, Elvira Skinner, and W.M. Bottoms; (second row) Larcena Swittles, Frank E. Martin, Greta Johnston, Jay Johnston, and R.J. Martin. Pastors and members of Reformed Presbyterian played an important role in Selma's African American community for many years. Rev. George M. Elliot (pastor, 1877–1890) was one of the founders of the Alabama State Teachers Association and served as its president. Sophia P. Kingston founded the first school in east Selma in 1905 and ran it for 17 years. The school at 2224 Alabama Avenue bears her name. Her brother Rev. Solomon Kingston, pastor of Reformed Presbyterian from 1903 to 1927, urged the Selma City School Board to establish a school in North Selma, which became Payne Elementary. (BRC.)

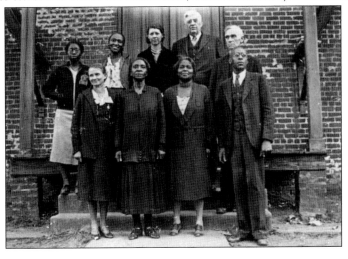

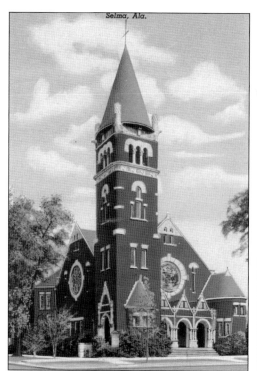

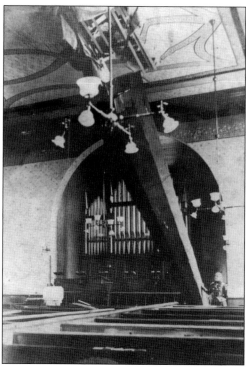

The Methodists were the first denomination to organize in Selma, with Rev. Daniel Norwood uniting 11 members together in a wooden church at the corner of Dallas Avenue and Church Street, the very lot laid aside for their use by the Selma Land Company in 1817. Originally called the First Methodist Church, it is now known as Church Street United Methodist. The present building is the third structure to house the congregation. The first was a little wood-frame building, and the second was a brick structure completed in 1856. In 1890, a severe storm hit the church during choir practice, toppling the steeple and sending it crashing down into the sanctuary. Thankfully, nobody was hurt, and the congregation voted to rebuild the church. Completed in 1902, the beautiful Romanesque building includes a stained-glass rose window with each petal memorializing one of the founders. In 1907, the church held the memorial services for US senator John Tyler Morgan. The funeral procession included military units, Confederate veterans, a band, carriages of government officials, and a hearse pulled by 12 white horses. The sanctuary underwent a complete restoration in 2002. (Selma–Dallas County Public Library.)

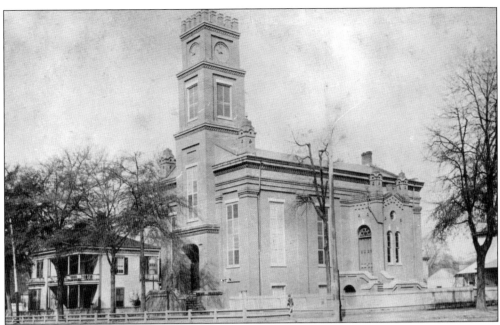

The Reverend Francis Porter organized a Presbyterian congregation in Selma on December 22, 1838. Within a year, a wooden building was erected at the corner of Dallas and Washington Streets. Later, under the leadership of Dr. Richard B. Cater (1845–1851), First Presbyterian Church moved to its present location at the corner of Dallas and Broad Streets and work was begun on a brick structure in 1847. In 1893, the old church was torn down, and a new one was built at a cost of $25,000. Housed within the church's tower is the official Selma city clock, a Seth Thomas, installed in 1893. The clock remains today, a landmark for the people of Selma. The church, now named Cornerstone, underwent major remodeling in 1967, and in 1990 an adjacent building was purchased and now serves as a senior nutrition center and church facility. (Selma–Dallas County Public Library.)

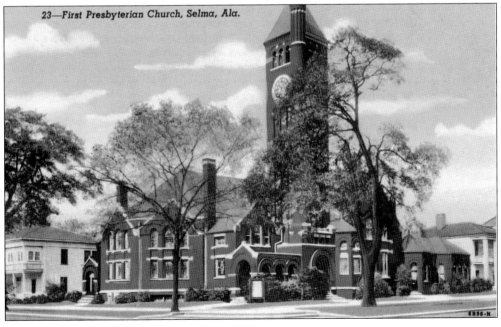

23—First Presbyterian Church, Selma, Ala.

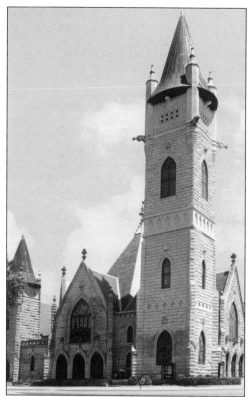 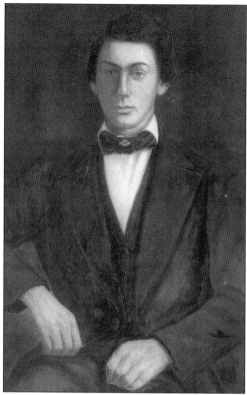

Selma's Baptists first organized in May 1842 but did not have a building of their own until 1850, when they erected a building at the corner of Church Street and Alabama Avenue. First Baptist's pastor, Nobel Leslie DeVotie, resigned his post to serve as chaplain to the Selma troops leaving for the Civil War. Nobel drowned in Mobile Bay in 1861, and the first Confederate flag ever used was draped over his casket. After the Battle of Selma, First Baptist was the only church open for Sunday services. The Federal officers attended services alongside their Confederate brothers and family members. The present church was built in 1900 at Dallas Avenue and Lauderdale Street. The High Gothic gargoyles serve as rainspouts on the massive stone tower, and the sanctuary houses two Tiffany windows. First Baptist has produced several daughter churches over the years. Among these are First Baptist Church on Martin Luther King Jr. Street (1894), Central Baptist/ Valley Grande (1896), West End Baptist (1943), Northside Baptist (1944), Water Avenue Baptist (1945), Elkdale Baptist (1952), Selmont Baptist (1946), Fairview Baptist (1956), and Summerfield Baptist (1973). (Selma–Dallas County Library and Madden & Associates.)

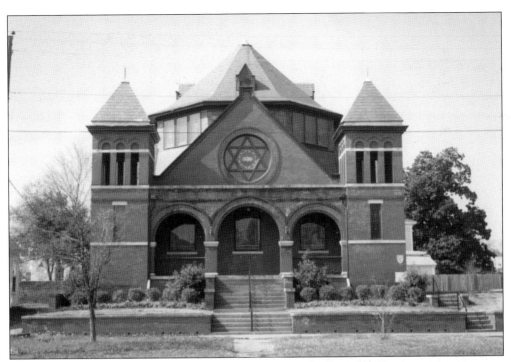

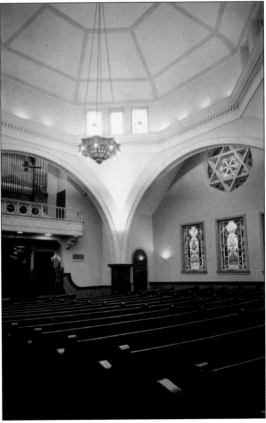

Jewish settlers came to Selma in the early 1800s, and on July 10, 1870, they formed a congregation under the name Mishkan Israel, which means "the dwelling place of Israel." The first formal services were held in Harmony Hall in September. For many years, the congregation was able to hold services only twice a year, on Rosh Hashanah and Yom Kippur. In 1876, the congregation rented the old Episcopal church, and Rabbi G.I. Rosenberg began offering regular services. On June 13, 1899, ground was broken on the new synagogue, and the present Temple Mishkan Israel was dedicated in February 1900. Located on the north side of Broad Street, the temple's facade is constructed of red brick with the entrance featuring a three-arched portico. The temple is of Romanesque design and is comprised of two symmetrical towers and a raised octagonal roofed sanctuary. During the 90th anniversary service, Rabbi Louis Binstock defined a temple as "a place of reunion and remembrance; a place of refuge and rest; a place to repent and be redeemed; and a place of rededication and reconsecration." (Selma–Dallas County Public Library and BRC.)

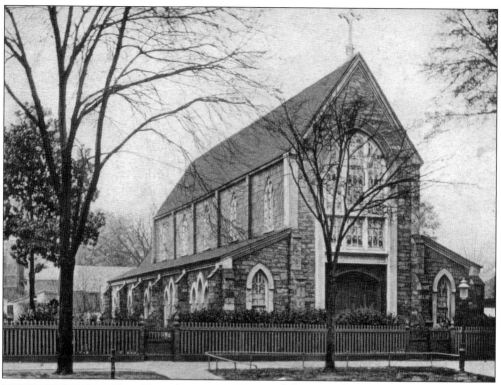

Selma's Catholic community dates back to 1850, when the small congregation met in private homes for Masses. Selma received its first resident pastor, Fr. Andrew Gibbons, in 1862. Construction began on the Church of the Assumption of the Blessed Virgin in 1869, and stones from the old Confederate arsenal were used as building material. German architect A. Von Fichert designed the Gothic church. In later years, the church erected St. Andrew's Hall to serve as a boy's school. In 1881, a convent and girl's school named Sacred Heart Academy was established on Broad Street; it moved to Summerfield Road in 1950. Selma's second Catholic parish was founded in 1937 by the Society of Saint Edmund (or Edmundites) to serve the city's African American community. In 1970, Bishop John May asked the parishioners of Assumption and Saint Elizabeth's to merge into one integrated parish. The Most Reverend Moses B. Anderson (at left), SSE, auxiliary bishop of Detroit, was born and raised in Selma. (Selma–Dallas County Public Library.)

The Entre Nous Club was founded in 1942 by three young Selma women: Mary Emma Bynum, Osceola Dewey Clark Brown (Oscie), and Mary Ellen Williams. In the beginning, the club was named the Servitors Club but was later changed to Entre Nous Club. The French words are translated to mean "between ourselves or us." The club is devoted to civic and social service. Attending the Garden Party at the home of Ruth Williams on Summerfield Road are, from left to right, Osceola Brown, Rosie Regan, Agnes Stone, Ruth Phillips, Corsetta Boyd, Gracie Phillips, Mary Emma Bynum, Ruth Williams, Mary Ellen Williams, Juanita Sherrod, and Dorothy Brown. The club founded the former Wilson Baker Home for Boys, furnished the first playground equipment for handicapped children at the old Knox Academy, and continues to play an active role in the Selma community. (Dorothy Brown.)

Mayor George P. Evans, and his new bride, Jeannie Wooten, are pictured in November 1966 at a reception held at the home of Tom and Ruby Hrobowski. Prior to becoming mayor, George served as Dallas County School superintendent and president of the Selma City Council. He was elected mayor in 2008 and reelected in 2012. (Evans family.)

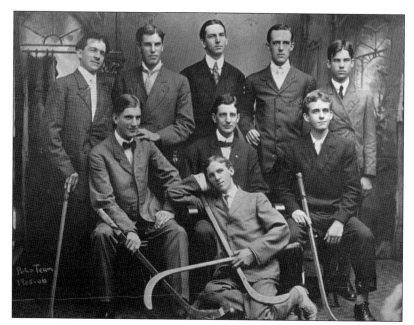

The 1905–1906 Selma polo team was comprised of, from left to right, (first row) James Veltz; (second row) Herbert Lilly, Frank Warmer, and E.E. Helmer; (third row) Albert Bear, Henry Phillips, Hal Ellis, Robert Young, and A.D Butler. (BRC.)

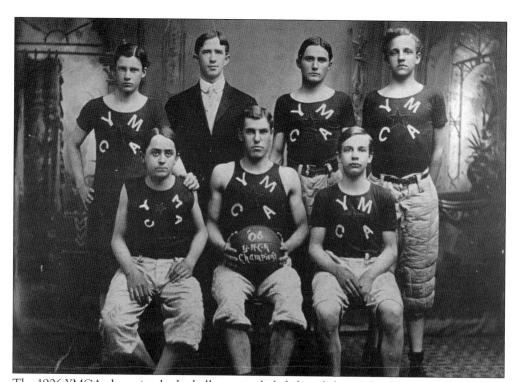

The 1906 YMCA champion basketball team included, from left to right, (first row) Bart Barker, Henry Phillips, and Curtis Gowan; (second row) Fred DuBose, Gilbert Green, Frank Barker, and Ralph Nelson. Fred would become Dr. DuBose, founder of DuBose Sanitarium and operator of the Vaughn Hospital. (BRC.)

By the early part of the 20th century, prosperity had returned to Selma, and its citizens created ways to relax after a long workweek. The Selma Race Track, built in 1907, was located between Franklin Street and Range Line Road (now Marie Foster), just north of First Avenue. The grandstands were packed on Fridays and Saturdays as the town's elite came out to watch and race their horses and dogs. (Selma–Dallas County Public Library.)

Elkdale Park was another favorite spot with five beautiful acres, a swimming hole, and covered pavilions. The park was located off North Broad Street, just south of Highland Avenue. Elkdale Park was a favorite spot of Edgar Cayce and his family. The city's network of rails carried residents throughout downtown to Elkdale Park, the racetrack, and Rowell Field. (BRC.)

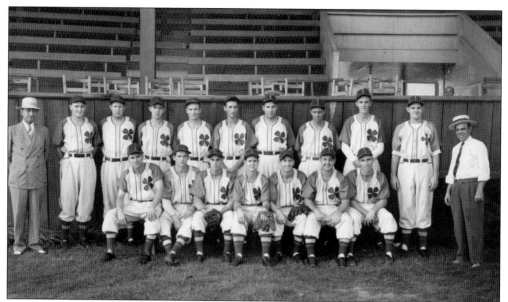

Maurie Bloch, pictured above on the far left in suit and top hat, was born and raised in Selma. While he operated many business enterprises, he is most remembered as the owner of the Selma Cloverleafs. Bloch, along with Harry W. Gamble and Fred Hering, began operating the minor-league baseball team in 1927. The team played in the Southeastern League and was at one time affiliated with the Chicago Cubs. The gentleman on the right is Harper Hill. Thousands of spectators came to Rowell Field to watch baseball games. Unfortunately, by the early 1950s the Cloverleafs became a thing of the past. Rowell Field was remodeled and renamed Bloch Park in 1957. (BRC.)

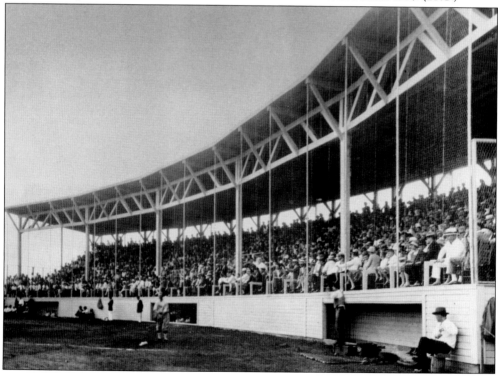

Selma has had a long love affair with parades. Fraternal organizations, patriotic groups, schools, and the military all loved to parade down Broad Street. Red, white, and blue bunting draped the fronts of buildings, and huge banners were strung across the road. Each parade brought out local bands, and hundreds of people would find their way downtown. (BRC and Craig Field Airport and Industrial Complex Archive.)

DISCOVER THOUSANDS OF LOCAL HISTORY BOOKS
FEATURING MILLIONS OF VINTAGE IMAGES

Arcadia Publishing, the leading local history publisher in the United States, is committed to making history accessible and meaningful through publishing books that celebrate and preserve the heritage of America's people and places.

Find more books like this at
www.arcadiapublishing.com

Search for your hometown history, your old stomping grounds, and even your favorite sports team.